720.92

FRANK LLOYD WRIGHT'S

TALIESIN

FRANK LLOYD WRIGHT'S

TALIESIN

ILLUSTRATED BY VINTAGE POSTCARDS

RANDOLPH C. HENNING

THE UNIVERSITY OF WISCONSIN PRESS

The University of Wisconsin Press
1930 Monroe Street, 3rd Floor
Madison, Wisconsin 53711-2059
uwpress.wisc.edu

3 Henrietta Street
London WCE 8LU, England
eurospanbookstore.com

Library of Congress Cataloging-in-Publication Data
Henning, Randolph C.
Frank Lloyd Wright's Taliesin : illustrated by vintage postcards / Randolph C. Henning.
p. cm.
Includes bibliographical references.
ISBN 978-0-299-28284-4 (pbk. : alk. paper)
1. Taliesin (Spring Green, Wis.)—Pictorial works. 2. Wright, Frank Lloyd, 1867–1959—Homes and haunts—Wisconsin—Spring Green. 3. Postcards—Wisconsin—Spring Green. I. Title.
NA737.W7H44 2011
720.92—dc22
2010046466

To Bruce Brooks Pfeiffer, Oskar Muñoz, Margo Stipe, and Indira Berndtson of the Frank Lloyd Wright Archives, for their resolute commitment to the living legacy of Frank Lloyd Wright; to the passionate staff of Taliesin Preservation, Incorporated, for their dedicated work in the preservation of Frank Lloyd Wright's Taliesin; and always to Maggie, Michael, and Christopher.

Taliesin—a house, an architectural studio, a farm, a school, a life of music, art, dance, and design—can best be understood as a manifestation of the aesthetic and cultural ideals of Frank Lloyd Wright. Wright's most personal composition is the consummate example of the architectural self-portrait. In its landscaping, gardens, buildings, art, and furnishings, Taliesin embodies his frontier spirit and his cosmopolitan tastes, both characteristics of his intricate intelligence and his romantic idealism.

—Kathryn Smith, *Frank Lloyd Wright's Taliesin and Taliesin West*

CONTENTS

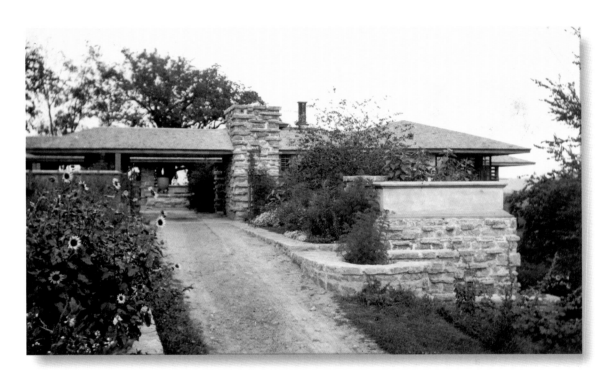

This beautifully seductive postcard presents an early view of the final approach to Frank Lloyd Wright's Taliesin, an entirely organic, natural, and honest masterstroke in his life work. As Wright wrote in his autobiography, "And so began a 'shining brow' for the hill, the hill rising unbroken above it to crown the exuberance of life in all these rural riches."

Frank Lloyd Wright (1867–1959) is regarded today as the greatest American architect who ever lived, as one of the creators of modern architecture, and as one of the most flamboyant celebrities of the twentieth century. His reputation certainly derives from his well-known masterworks such as the Frederick C. Robie House in Chicago, Illinois, and Fallingwater in Mill Run, Pennsylvania; his exquisite Prairie houses in the Midwest; his highly original Usonian houses all over the nation; and from his monumental public buildings such as Unity Temple in Oak Park, Illinois, and the Guggenheim Museum in New York. His renown rests also on his brilliance as the designer of one of America's architectural landmarks, Taliesin, near Spring Green, Wisconsin. Despite the fact that it was a work Wright redesigned, remodeled, and enlarged throughout his lifetime, surprisingly few vintage photographs have been published to document its evolution. As a result, dedicated Wright followers and all lovers of beautiful buildings will welcome the images in this volume.

The full historic and artistic importance of the postcards that Randolph Henning has collected for this book can only be understood by going back to the origins of Taliesin. An outcast architect was completing a house, studio, and farm for the woman he loved—a woman, Mamah Borthwick, who was not his wife. For the first time, the two kindred spirits could live in a home they had created together. Feeling misunderstood and shunned by the greater society around them in December 1911, the couple retreated into a self-contained world filled with architecture, literature, and art.

In the first decades of Taliesin's history, it suffered more than one instance of bad fortune. In August 1914, while Wright was away in Chicago

on business, a deranged servant killed Mamah, her two young children, and four others while the residential wing burned to the ground. Wright was desolate and took solace in rebuilding almost immediately. Fate struck again in April 1925 when an accidental electrical fire could not be contained and the residence was destroyed yet again. It is clear through each rebuilding that Wright kept true to the artistic value of the iconic design. As he enlarged and expanded Taliesin in the decades ahead, he carefully maintained the architectural integrity of the whole by adhering to the same materials of limestone, warm ocher plaster, and weathered wood shingles.

The reader can follow these changes in the pages that follow. Of special importance is a set of real photo postcards that can be identified as a single group by the legend "Frank Lloyd Wright Home," which is printed in white block letters in the lower margin of each card. These images, which appear here in sequence for the first time, document a brief moment in the history of Taliesin between 1911 and 1914. Up until recently, the only known photographs dating from this specific period were taken by a professional photographer in the summer of 1912. They appeared in *Architectural Record* in January 1913. But a few years ago, a different set, also from the first year of Taliesin's existence, were auctioned off on Ebay. These photographs, which have never been published as a group, were donated to the Wisconsin Historical Society in Madison. Henning's postcards depict Taliesin in 1913 and taken altogether reveal for the first time that Wright was revising and expanding his creation almost from the beginning. They are a rare find.

The subject of this book is of unique value for several reasons: first, as documentation of Wright's house and other buildings on his six hundred-acre estate; second, for the amount of detail they provide; and third, for the insight they present into the architect's restless sense of invention. This publication is a welcome addition to the history of one of America's most cherished houses.

—Kathryn A. Smith

INTRODUCTION

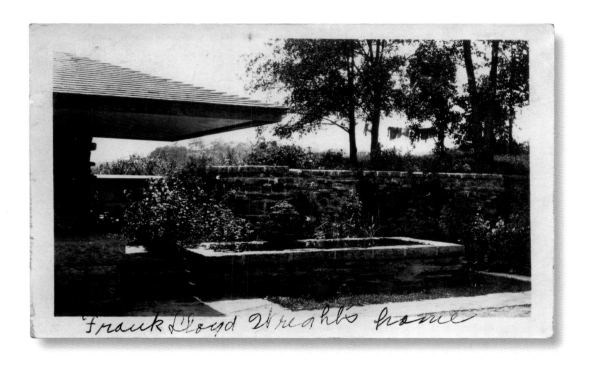

Frank Lloyd Wright's home

A postcard of the flora and fountain at Frank Lloyd Wright's Taliesin, presenting a part of the entry sequence sheltered by the cantilevered roof of the carriage porch porte cochere and stone retaining walls. Looking in the western direction toward the hilltop beyond, one can see clothes strung out to dry between two trees at the upper right of the image.

"The Valley" they all lovingly called it in after life, and lovable it was, lying fertile between two ranges of diversified soft hills, with a third ridge intruding and dividing it in two smaller valleys at the upper end. A small stream coursing down each joined at the homestead and continued as a wider stream on its course toward the River. The lower or open end of the Valley was crossed and closed by the broad and sandbarred Wisconsin, and from the hills you could look out upon the great sandy and treeless plain that had once been the bed of the mighty Wisconsin of ancient times.

When the virgin soil was broken by the grandfather and his sons, friendly Indians still lingered in the neighborhood.

—Frank Lloyd Wright, *An Autobiography,* 5–6

This "Valley" was where the American architectural icon Frank Lloyd Wright (1867–1959) built his beloved Taliesin.[1] Taliesin, a Welsh word meaning radiant or shining brow, was the name he gave his home that he designed and built in 1911 on ancestral land at Hillside in the Town of Wyoming nearly two and a half miles south of Spring Green in southwestern Wisconsin. Taliesin was placed into the brow of a hill, providing an intimate relationship with the land while, with it's commanding presence, overlooking the "Valley of the God-Almighty Joneses" below.[2] It represented a synthesis of his earlier prairie inspired work with his more recent experiences acquired during his European sojourn with Mamah Borthwick Cheney (1869–1914) at Villino Belvedere in the hills of Fiesole just outside of Florence, Italy. It became what is arguably his ultimate natural organic solution——a home built of the hill, in nature with it, and not in dominance of it. Wright wrote, "I knew well that no house should *ever* be *on* a hill or *on* anything. It should be *of* the hill. Belonging to it. Hill and house should live together each the happier for the other."[3]

Taliesin both truly and lovingly embraced its site, spreading and extending like roots of a tree. "Stone stepped up like ledges on to the hill and flung long arms in any direction that brought the house to the ground."[4] And Taliesin was functionally more than a dwelling providing shelter from the elements. It was also his architectural studio and provided for farming his land, "a complete living unit genuine in point of comfort and beauty, yes, from pig to proprietor. The place was to be self-sustaining if not self-sufficient."[5] It too was psychologically more than shelter. It was built to also provide refuge, retreat, and sanctuary for Wright and his soul mate, Mamah Borthwick,[6] from the mores of society, a fortress against social hostility. Wright scholar Neil Levine succinctly described the larger picture when he wrote, "Taliesin was therefore never just a house—not merely a building, that is. It signifies a domain, a country estate. . . . Taliesin was intended from its outset to tell a story with a specifically autobiographical meaning forming an image of Wright's personal life woven into the fabric of his family's land."[7]

Originally Taliesin was located on thirty-one and a half acres of land purchased in April 1911 by Wright's devoted mother, Anna Lloyd Wright (1838–1923), evidently for her son. "Work, life and love I transferred to the beloved ancestral Valley where my mother foreseeing the plight I would be in had bought the low hill on which Taliesin now stands and she offered it to me now as a refuge."[8] Curiously, the original architectural drawings (dated April 1911) identified the project as a "Cottage for Mrs. Anna Lloyd Wright." Construction began the following month. Mamah Borthwick moved into Taliesin in the fall of 1911 with Frank Lloyd Wright permanently in residence a few days before Christmas 1911. Whether the

initial design was truly intended for his mother or was a calculated ruse to avoid potential (and real) legal, financial, social, and moralistic complications, his mother was not in the picture when Taliesin was finished. Nor was scandal eluded. The locals soon saw Wright's home not as Taliesin but as the "love cottage."[9]

Wright was intimately familiar with the property, one of his favorite places as a boy.[10] Beginning at age ten, Wright worked a half dozen summers on his Uncle James Lloyd Jones's (1850–1907) farm in the Valley. As Wright wrote about himself in the third person in his autobiography, "He went away from Mother, books, music and city boys and father and little Maginel and Jane, idle dreams and city streets to learn to add 'tired' to 'tired' and add it again—and add it yet again."[11] He grew to love the land. "My mother so deeply loved life in the Valley that I am sure I nursed at the Valley's breast when I nursed at hers. Terrestrial beauty so grows on me as I grow up that the longer I live the more beautiful it becomes. A walk in our countryside when the shadows are lengthening is to look and drink a poignant draught—and look and drink again. I wonder if anything there can be in 'Heaven' is so lovely. If not, how tragic Death must be! Death or no death, I see our countryside as a promise never to be broken."[12] Taliesin was an example of what he always sought to accomplish: "A good building makes the landscape more beautiful than it was before that building was built."[13]

Originally Taliesin was Wright's name for the house, but over time it was applied to the entire estate, which eventually grew to encompass more than 1,100 acres of land and would include the Hillside Home School campus, the Romeo and Juliet windmill, Tan-y-deri, and the

Midway farm complex by the time of Wright's death in 1959. Hillside Home School was a progressive co-educational school run by Wright's aunts Elinor Lloyd Jones (1845–1919; also know as Ellen and Nell) and Jane Lloyd Jones (1847–1917). The school started in 1885 on 120 acres of what had been family land in the Valley owned by their parents. Wright designed two of its numerous buildings—Wright's early Home Building, the original three-story shingle style school building designed in 1887, and the prairie influenced stone and wood building referred to as Hillside Home School II, designed by Wright almost fifteen years later. He may have had more input on other campus structures. Romeo and Juliet was a windmill that Wright's Aunts, in 1896, commissioned their young promising architect nephew to design in lieu of the more commonplace structures of the time. Tan-y-deri (a Welsh name meaning "under-the-oak") was the home Wright designed in 1907 for his younger sister Jane Lloyd Wright (1869–1953) and her husband Andrew Porter (1858–1948). In 1938, the Midway Farm complex (initially containing barns, with dairy and machine sheds added in the late 1940s), named for its location between Taliesin and Hillside Home School, was built to allow for the expansion of the farming operations after the establishment of the Taliesin Fellowship six years earlier. Hillside Home School II was also modified by Wright with the incorporation of a theater playhouse where the gymnasium existed; it was also expanded north of the arts and science wing with the addition of a large drafting studio.

The original built Taliesin complex was roughly 12,000 square feet in size. It grew over the years to eventually encompass nearly 24,000 square feet of enclosed interior space by the time of Wright's death in 1959.

It was forever fuel for Wright's constant experimentation and modifications, all reflecting changes in both functional and domestic circumstances, as well as aesthetic improvements. And the residential portion of the complex was twice totally lost to fires only to be rebuilt upon the ashes and ruined treasures.[14] Wright wrote, "Taliesin's radiant brow was marked now by both shame and sorrow but it should come forth and shine again with a serenity unknown before."[15] Incredibly, both tragedies spared the destruction of his architectural studio located just across a covered loggia from the residence. Bruce Brooks Pfeiffer recalled Wright saying, "It was as if God questioned my character, but not my work."[16]

The year 2011 marks the centennial anniversary of the design and construction of Taliesin.[17] Currently, the Taliesin complex consists of six hundred acres and is owned by the Frank Lloyd Wright Foundation. Undeniably, Taliesin is recognized worldwide as one of Wright's masterworks, arguably his best work and certainly one of the world's greatest architectural treasures. In 1976 the National Trust designated Taliesin a National Historic Landmark, the highest honor the federal government can bestow historic properties. In 1990 the Frank Lloyd Wright Foundation along with the State of Wisconsin created the nonprofit Taliesin Preservation, Incorporated, tasked to research, comprehend, stabilize, restore, preserve, and conserve the property and its historic but increasingly deteriorating structures. Assorted guided tours are offered to the public from May through October, starting from the off-site Frank Lloyd Wright Visitor's Center located on a hillside opposite Taliesin and above the Wisconsin River.

TALIE∫IN

The original entry gateway into Taliesin as seen from County Highway C, just west of State Road 23. At the base of the circuitous drive conforming with the natural contours up to Taliesin, this feature presented the passerby an unusual sight in the farmlands of rural southwestern Wisconsin. Wright's often-used planter urns (one obviously damaged, missing its cantilevered cap) sit atop limestone pier bookends, terminals to lower enveloping limestone walls. The design and detailing of the iron swing gates are consistent with Wright's iron trellis used within the courtyard of Taliesin, outside the drafting studio. A carved limestone plaque stating "Frank Lloyd Wright Architect" (with his early logo of a cross inside a circle inside a square), relocated from his earlier home and studio in Oak Park, was incorporated into the stone pier on the left. This postcard view (circa 1918) of the open gates includes a crooked sign, with a handwritten *No Admittance,* hung on the left gate post.

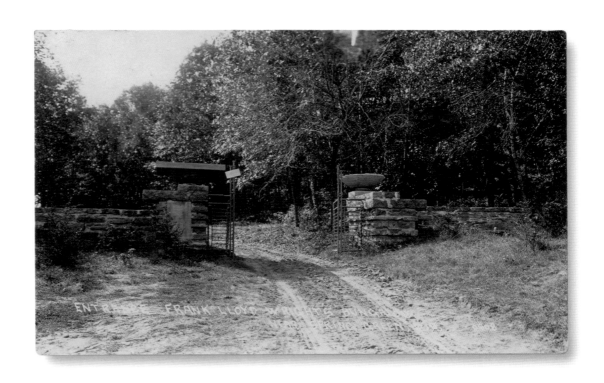

ENTRANCE FRANK LLOYD WRIGHT'S BUNG...

There must be a natural house, not natural as caves and log-cabins were natural, but native in spirit and the making, having itself all that architecture had meant whenever it was alive in times past. . . . Yes, there was a house that hill might marry and live happily with ever after. I fully intended to find it. I even saw for myself what it might be like. And I began to build it as the brow of that hill.

—Frank Lloyd Wright, *An Autobiography*, 168–69

This and the following eight postcards were printed in a series, indicated by the "Frank Lloyd Wright Home" in block letters on each.[1] The images were most likely taken on the same day (or a few contiguous days) and date sometime in February or March of 1914. This image, looking from below in the northern direction, presents a worm's-eye view of the southeastern side of Taliesin, with its low-slope, sheltering hipped roofs and plaster walls sitting atop a locally quarried limestone base and further anchored into the hillside by stone chimneys. The image also shows a rare view of Wright's use of grid tillage, a farming method common to the southern Italian countryside of Fiesole, to lay out this slope at Taliesin. He also used contoured tillage seen in Japan and a more controlled tillage used again in Italy for his orchards and vineyards. At the time, these methods all differed from Wisconsin's more common lined tillage.[2]

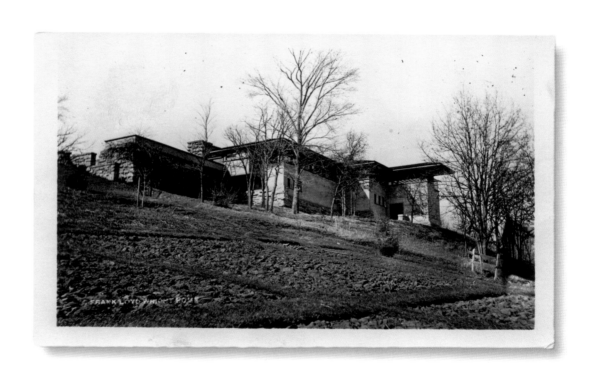

FRANK LLOYD WRIGHT HOME

Again, Taliesin! . . . When I am away from it, like some rubber band stretched out but ready to snap back immediately the pull is relaxed or released, I get back to it happy to be there again.

—Frank Lloyd Wright, *An Autobiography*, 368

Standing on a stone retaining wall adjacent to the approach road, this is a postcard view of the southwestern side of Taliesin where residents and visitors alike originally entered the complex. The house, with its obvious strong horizontal emphasis, appears to step out into space at the right, anchored into the hill and sitting atop various limestone retaining walls. An automobile is shown entering what Wright originally called the carriage porch, sheltered by a porte cochere, both signaling entry into the interior arrival court. The limestone chimney is for the fireplace in the workmen's dining room.

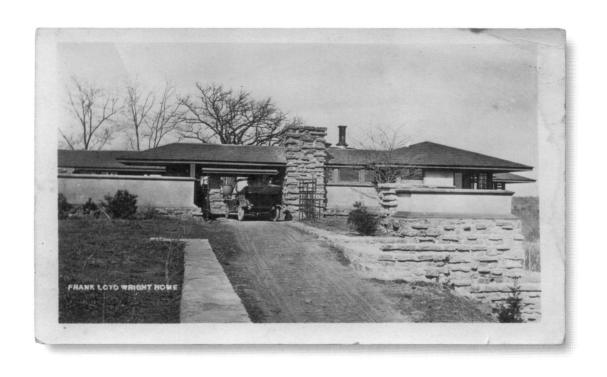

FRANK LOYD WRIGHT HOME

A house of the North. The whole was low, wide and snug, a broad shelter seeking fellowship with its surroundings. A house that could open to the breezes of summer and become like an open camp if need be. With spring came music on the roofs, for there were few dead roof-spaces overhead, and the broad eaves so sheltered the windows that they were safely left open to the sweeping, soft air of the rain. Taliesin was grateful for care. Took what grooming it got with gratitude and repaid it all with interest.

Taliesin's order was such that when all was clean and in place its countenance beamed, wore a happy smile of well-being and welcome for all.

It was intensely human, I believe.

—Frank Lloyd Wright, *An Autobiography*, 174

This postcard view of the interior arrival courtyard, another in the early 1914 series, shows a pubescent but honest Taliesin. The essential grammar of materials, the palette of natural materials used by Wright are easily discernable—a native sand-limestone from a stone quarry a mile away placed in a stratified manner (like natural outcropping ledges seen in the region), exterior plaster colored to match the tawny gold sand in the Wisconsin River below (Wright actually used sand from the river in the plaster mixture), finished wood the color of the gray tree trunks, and wood roof shingles that would weather silver-gray to match the tree branches. The view, looking east-southeast, presents the living quarters flanked by the carriage porch porte cochere at the right and the open but roofed entry loggia (separating the living quarters from the architectural studio) at the far left. The monitor seen on the roof at the far left is an element that existed only in this design with the original Taliesin.

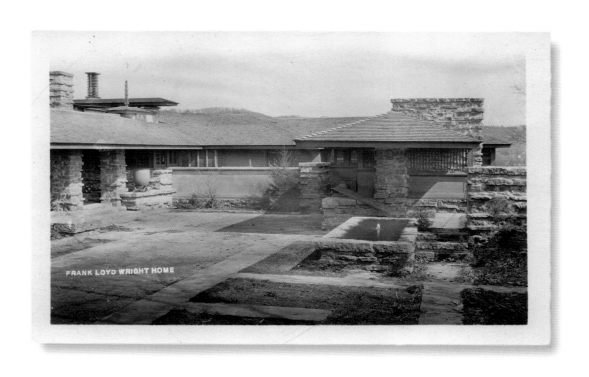

FRANK LOYD WRIGHT HOME

This modest human programme in terms of rural Wisconsin arranged itself around a hilltop in a series of four varied courts leading one into the other, the courts all together forming a sort of drive along the hillside flanked by low buildings on one side and by flower gardens against the stone walls that retained the hill-crown on the other.

The hill-crown was thus saved and the buildings became a brow for the hill itself. The strata of fundamental stone-work kept reaching around and on into the four courts, and made them.

—Frank Lloyd Wright, *An Autobiography*, 171

Providing a contextual sense of Taliesin within the Valley, this is another postcard from the early 1914 series. From an elevated position (most likely within or on top of the hayloft or perhaps the Hill Tower), this bird's-eye view is an easterly look primarily of the long studio workshop of Taliesin, with the rolling hills beyond. Wright's living quarters is at the right of the image and the steps to the semicircular tea circle, with its two huge oaks, are in the right foreground. *The Flower in the Crannied Wall* statue is in situ atop a stone retaining wall, just behind a horse and buggy, with Wright possibly in the driver's seat. The far left of the image provides evidence of ongoing construction with the expansion of the drafting studio.

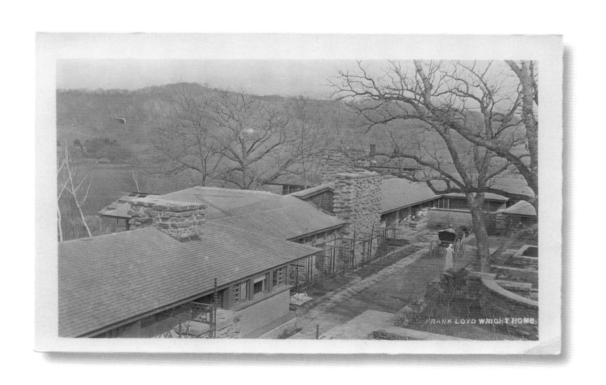

With a view similar to the previous postcard, this postcard from the early 1914 series provides a slightly elevated view, from the hill garden looking in the easterly direction across the interior arrival courtyard, of the open but roofed loggia (just to the left of the large Japanese bronze vessel) connecting the personal and professional wings. A hint of the carriage porch porte cochere is at the far right, just above the fountain. The stone mass is the fireplace chimney that warmed the drafting studio.

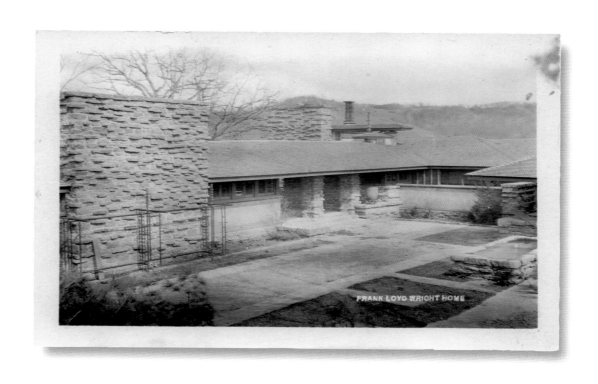

FRANK LOYD WRIGHT HOME

Another in the early 1914 series, this postcard looks to the north from the interior arrival court. The southwest side of the drafting studio is evident at the right, with the small apartment jutting out and, beyond, the upper hayloft bridging across to the Hill Tower and hilltop. Hinted at the far left are the stone steps up to the tea circle just below the *Flower in the Crannied Wall* statue. The original wooden trellis has now been replaced with similar ironwork. The small apartment included a sitting room with fireplace, a kitchen and dining alcove off the sitting room, and a bedroom chamber with adjoining bathroom.

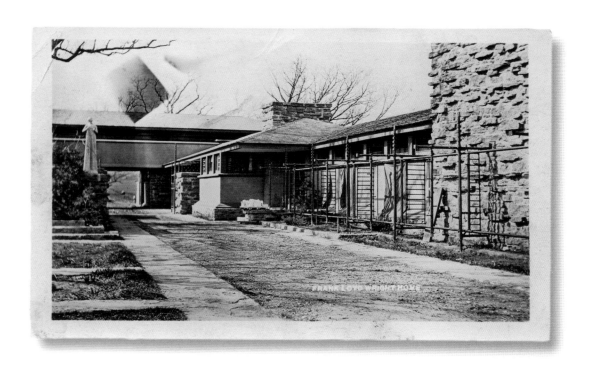

FRANK LOYD WRIGHT HOME

The seventh postcard from the series dating to early 1914 provides a close-up view, looking in the northern direction, of the southwest side of the small apartment that Wright designed at the northwest end of the architectural studio wing. Just outside the door to the drafting room a damaged plaster model of Wright's 1905 Oak Park opus Unity Temple sits on top of the limestone foundation wall (in the middle right of the image). Wright's original intention for the small apartment remains a mystery. It wasn't included on the first "Cottage for Mrs. Anna Lloyd Wright" floor plan but was soon added onto subsequent plans.[3] It quite possibly was intended to be used by Wright's mother. However, as early as 1913, the small apartment became a bunkhouse used by the draftsmen in residence.

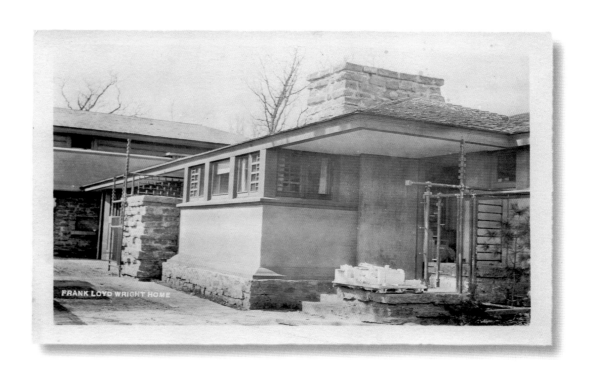

FRANK LOYD WRIGHT HOME

From just beyond the rear gates, just outside the interior entrance courtyard, a horse and buggy (and quite possibly Frank Lloyd Wright) is seen waiting in the drive. Another postcard from the early 1914 series, this view is looking southeast. Hints of the farming components are seen at the immediate left (the door to the carriage garage is seen at the far left) with drafting areas beyond and living quarters in the distant background.

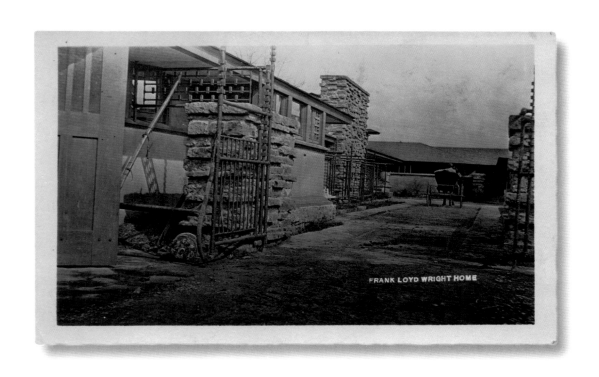

FRANK LOYD WRIGHT HOME

The last of the series of postcards taken of Taliesin in early 1914 shows the southeast side of the Hill Tower, which terminated the generally U-shaped Taliesin complex beyond the upper hayloft upon the hill garden and above the tea circle. The stone steps to the tea circle and hill garden beyond, along with the twin towering oak trees, are clearly evident in this image, just to the left of the *Flower in the Crannied Wall* statue.

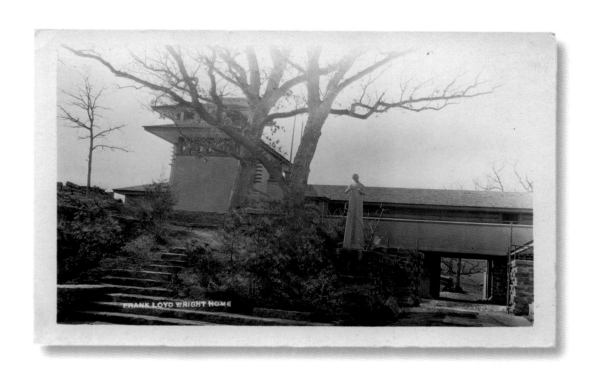

FRANK LOYD WRIGHT HOME

Country masons laid all the stone with the stone-quarry for a pattern and the architect for a teacher. The masons learned to lay the walls in the long, thin, flat ledges natural to the quarry, natural edges out.

—Frank Lloyd Wright, *An Autobiography*, 171

Viewed from the loggia in the northwesterly direction, this postcard looks across the interior courtyard and includes the stone retaining walls securing in place the tea circle and hill garden beyond. The elevated hayloft is seen morphing into the Hill Tower, partially obscured by the twin oaks of the tea circle.

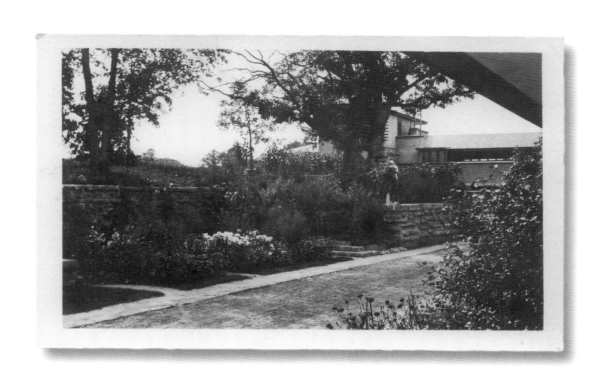

While this view is almost the same as that on page 23, this postcard shows a later, more lushly landscaped interior courtyard of Taliesin. The abundant greenery has overtaken the trellis alongside the studio wing to the right, to the extent of its traveling up to the roof in two places. At the far right multiple ears of corn for the birds are seen hanging off the trellis. The iron gate at the far end of the interior courtyard is seen closed. And the *Flower in the Crannied Wall* is now nearly engulfed by the copious flora beyond the steps to the tea circle and hill garden.

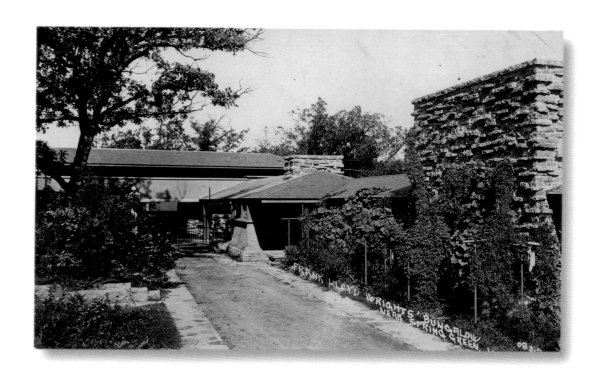

Finally it was not so easy to tell where pavements and walls left off and ground began. Especially on the hill-crown, which became a low-walled garden above the surrounding courts, reached by stone steps walled into the slopes. A clump of fine oaks that grew on the hilltop stood untouched on one side above the court. A great curved stone-walled seat enclosed the space just beneath them.

—Frank Lloyd Wright, *An Autobiography*, 170

What is most commonly referred to as the Taliesin tea circle, this postcard (postmarked August 14, 1920) identifies as "the Exhedra." Built adjacent to the hill-crown at Taliesin, with the studio wing in the background to the right and stable, farm components, and upper hayloft bridging across the courtyard exit to the far left, the tea circle was often used as a gathering place. Two Ming-dynasty jars are positioned on the stone seat as terminals. Tragically, the oak tree evident in this image is no longer extant as it was toppled in an exceptionally strong summer storm on June 18, 1998. The sender of this postcard wrote on the back, "This is the scene of the Love Cottage I was telling you about."

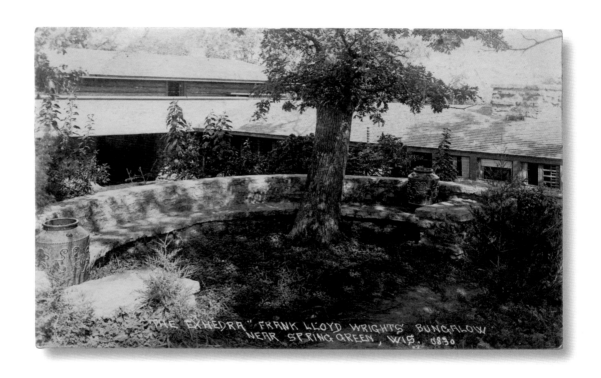

"THE EXHEDRA" FRANK LLOYD WRIGHT'S BUNGALOW NEAR SPRING GREEN, WIS. 6830

On the verso of this postcard (circa mid- to late 1920s) the sender wrote, "This is now changed—the tower being servant's quarter and the dovecote removed. Note dinner bell. Wright family dining room in foreground."[4] Taliesin's Hill Tower is not too distant from the tea circle and commands a prime position near the hilltop at Taliesin. While it survived both tragic fires intact, it nonetheless was not immune to Wright's persistent penchant for change (both in use and aesthetic), as the note above so indicates. The Hill Tower was originally planned primarily as a farm unit but was later adapted for housing and Fellowship functions. Looking in the northern direction, the image shows an early view of the building with the wooden dovecote against the side of the tower and the horizontal expansion of a dining room added by Wright at the left. Note the dinner bell on the stone wall near the dovecote.

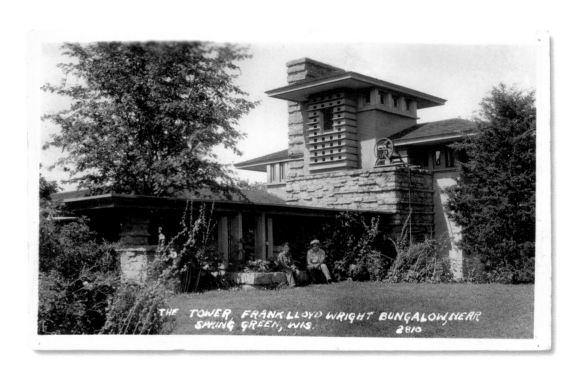

THE TOWER, FRANK LLOYD WRIGHT BUNGALOW NEAR SPRING GREEN, WIS. 2810

Yes, Taliesin should be a garden and a farm behind a real workshop and a good home.
 I saw it all, and planted it all and laid the foundation of the herd, flocks, stable and fowl as I laid the foundation of the house.

—Frank Lloyd Wright, *An Autobiography*, 170

This is a rare view of the terminating farming end of the long "west wing," as the postcard states, of Wright's bungalow. The wing actually runs in the northwest–southeast direction. This particular end contains areas for farm functions. The double door in the center of the image, with its upper shutters open, is actually the entrance into the interior arrival motor court, the work area, and residence beyond. The long horizontal structure above is the enclosed but open-air hayloft that bridges over from above the main floor of the work wing to the hilltop to the right. To the left of the double doors is where the horse stalls existed and to the right the cow barns, feed bins, milk storage, and automobile garage are partially seen. The image is one of the postcards from a series that were taken only days after the tragedy of August 15, 1914.

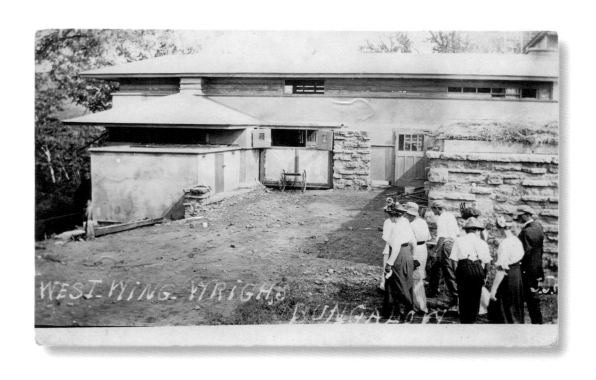

WEST-WING. WRIGHTS
BUNGALOW

The primary focus of this postcard (postmarked March 19, 1917) is the 1911 plaster replica of the 1903 terra cotta statue, *Flower in the Crannied Wall*, sitting within the interior courtyard of Taliesin atop a stone retaining wall below the tea circle and hill garden. The Hill Tower wing is seen in the background above, behind the towering oaks. *Flower in the Crannied Wall* is a statue of a female form constructing a crystalline tower. The original statue was created for the entrance foyer at the Dana residence in Springfield, Illinois, by sculptor Richard Bock (1865–1949) in direct collaboration with Frank Lloyd Wright.

Alfred Lord Tennyson's poem "Flower in the Crannied Wall" (1868) was inscribed on the back of the statue.

Flower in the crannied wall
I pluck you out of the crannies;—
Hold you here, root and all, in my hand,
Little flower—but if I could understand
What you are, root and all, and all in all,
I should know what God and man is.

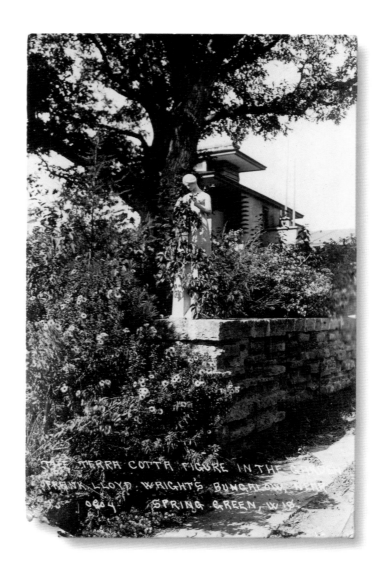

THE TERRA COTTA FIGURE IN THE GARDEN
FRANK LLOYD WRIGHT'S BUNGALOW,
0604 SPRING GREEN, WIS.

This postcard presents another view of Taliesin's entrance court looking at the open windows of the drafting studio. The loggia between the drafting studio and residence is at the far right with the stable and early farm components (with its upper hayloft) at the far left in the background. Included in the view is what is erroneously identified as an "Antique Chinese Bronze" resting upon a limestone base near the loggia steps greeting visitors. While the postcard is correct in stating that it is shown in situ at "Frank Lloyd Wright's bungalow near Spring Green, Wis.," it actually is a large Japanese vessel most likely dating back to the Meiji era (1868–1912). Wright probably purchased this artifact during his nearly four month visit to Japan with Mamah Borthwick in early 1913.

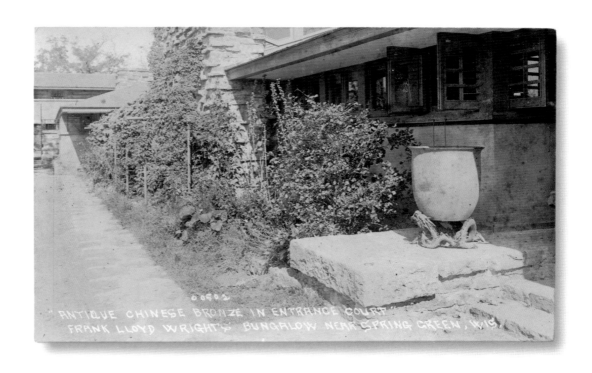

"ANTIQUE CHINESE BRONZE IN ENTRANCE COURT"
FRANK LLOYD WRIGHT'S BUNGALOW NEAR SPRING GREEN, WIS.

If the eye rested on some ornament it could be sure of worthy entertainment. Hovering over these messengers to Taliesin from other civilizations and thousands of years ago, must have been spirits of peace and good-will? Their figures seemed to shed fraternal sense of kinship from their places in the stone or from the broad ledges where they rested.

—Frank Lloyd Wright, *An Autobiography*, 174

Like the previous postcard, this one, postmarked August 9, 1937, again misidentifies the image of the large Japanese vessel, this time as "Brass kettle from Africa." The sender of the postcard wrote on its reverse side, "this kind of kettle you need when you get married, for soup."

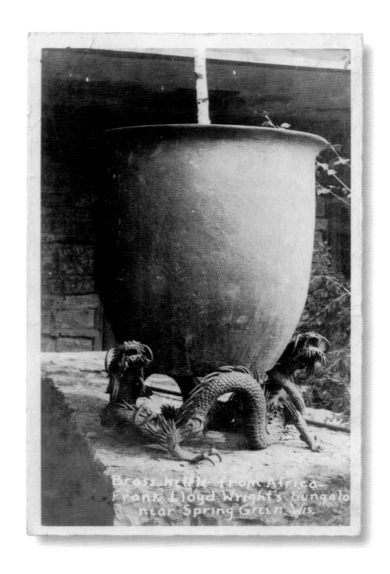

Brass kettle from Africa.
Frank Lloyd Wright's bungalo
near Spring Green, Wis.

As for objects of art in the house, even in that early day they were bêtes noires of the new simplicity. If well chosen, all right. But only if each were properly digested by the whole. Antique or modern sculpture, paintings, pottery, might well enough become objectives in the architectural scheme. And I accepted them, aimed at them often but assimilated them. Such precious things may often take their places as elements in the design of any house, be gracious and good to live with. But such assimilation is extraordinarily difficult. Better in general to design all as integral features.

—Frank Lloyd Wright, *An Autobiography*, 144—45

Frank Lloyd Wright's affection for Asian art is well known and documented. He passionately collected Japanese *ukiyo-e* woodblock prints as well as Chinese and Japanese artifacts, ceramics, bronzes, sculptural objects and statuary, textiles, stencils, carpets, clothing, and folding screens. Many if not most were purchased on his numerous trips to Asia before and during his work on the Imperial Hotel in Tokyo.[5] The cast iron "Chinese Idol" (more precisely described by Wright scholar Julia Meech as "Chinese Ming-dynasty cast-iron Guanyin in the pose of '*royal ease*'")[6] pictured in this postcard (circa mid- to late 1920s) is seen quietly assimilated. Displayed in a protected niche below the sheltering roof of the loggia near the entrance to Taliesin's drafting room, it seems perfectly situated upon the limestone window sill.

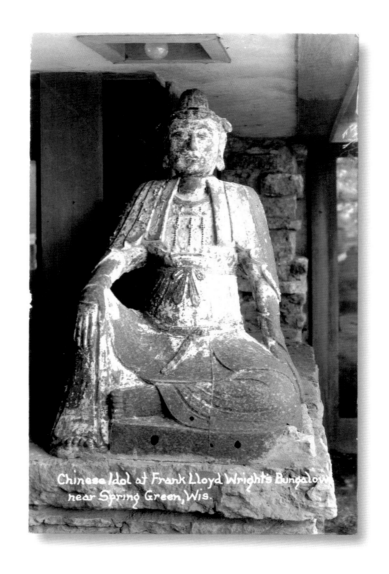

Chinese Idol at Frank Lloyd Wright's Bungalow near Spring Green, Wis.

The printer of this postcard handwrote onto the front, "View through the trees from hill after the fire—Wright's Bungalow." On August 15, 1914, while Frank Lloyd Wright was in Chicago working feverishly to complete his Midway Gardens opus, Julian Carlton, a recently hired servant, started the living quarters of Taliesin ablaze and went on a murderous rampage, killing seven people, including Wright's soul mate Mamah Borthwick and her two young children.[7] This image, taken only days after the tragedy, ominously presents a view of Taliesin looking east from the elevated position above upon the hilltop. Looking closely, the studio wing exists, along with the loggia columns. However, the residential portion is no longer extant. Frank Lloyd Wright can be seen in the middle of the image pointing up to the photographer.

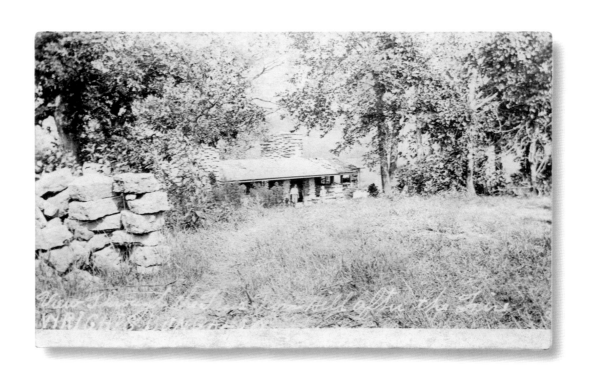

49

Thirty-six hours earlier I had left Taliesin leaving all living, friendly and happy. Now the blow had fallen like a lighting stroke. . . . [A] thin-lipped Barbados Negro . . . had turned madman, taken the lives of seven and set the house in flames. In thirty minutes the house and all in it had burned to the stone work or to the ground. The living half of Taliesin was violently swept down and away in a madman's nightmare of flame and murder.

—Frank Lloyd Wright, *An Autobiography*, 185

Taken within days after the tragic events of August 15, 1914, viewed (like the previous image but closer) from the elevated tea circle above, this image shows the ruins of Taliesin's residential wing to the right and the surviving architectural studio to the left. The open-air, roofed entry loggia that connected the two functions, where the man with the rifle sits at guard, helped in stopping the fire from spreading. The large collapsed roof of the porte cochere, laying on top of the courtyard fountain, once signaled and sheltered the carriage porch. The beauty of the hills beyond, the Valley of the God-Almighty Joneses, is a grim reminder of the stunning view that had existed outside Taliesin's living room.

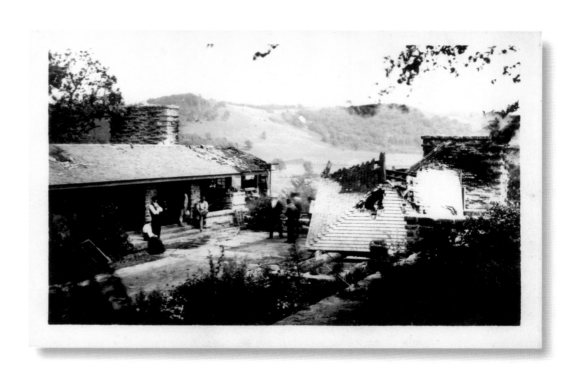

Another postcard in this horrendous series of images taken shortly after the August 15, 1914, fire, this view is from the lower level of the living quarters looking up in a westerly direction. Seen at the upper left are the remains of the limestone chimney of the fireplace that once warmed the workmen's dining room and helped to support the carriage porch roof. And in the upper right the kitchen ice box is still standing, above the cacophony of pipes, plaster, lath, and the charred wood. Over twenty people are seen in this image milling around, some talking while others survey the devastation. Ominously, someone marked the postcard with a white X on the rubble right of center, most likely marking the location of where, "The madman was finally discovered after a day or two hidden in the fire-pot of the steam boiler, down in the smoking ruins of the house."[8]

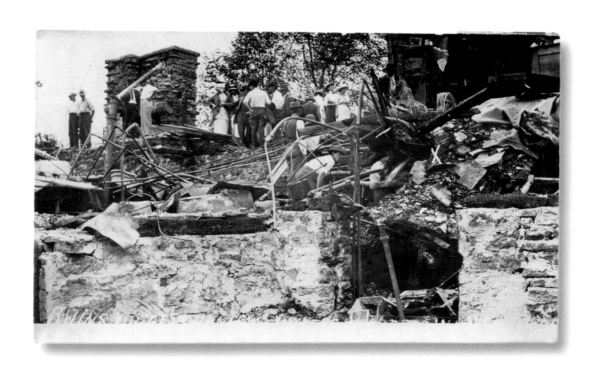

Another postcard taken shortly after the tragic events of August 15, 1914, showing seven women and two female children in among the staggering debris of Taliesin. Prominent in this view looking northwest from the ruins of the lower level is the living room's limestone fireplace, with the remnants of the kitchen to its left. The open portal in between was Taliesin's original entry hall.

Wright was devastated at both the loss of life and the loss of his Taliesin. "In the little bedroom back of the undestroyed studio workshop I remained in what was left of Taliesin I. . . . The gaping black hole left by fire in the beautiful hillside was empty, a charred and ugly scar upon my own life. . . . As I looked back at that time, I saw the black hole in the hillside, the black night over all. And I moved about in sinister shadows. Days strangely without light would follow the black nights. Totally—she was gone."[9]

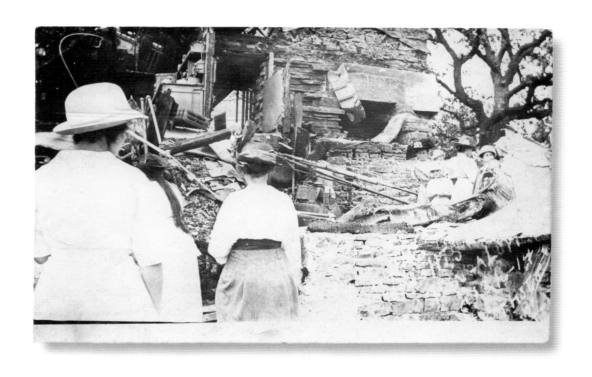

> The great stone chimneys stood black and tall on the hillside, their fireplaces now gaping holes. They stood there above the Valley against the sky, themselves tragic.
>
> —Frank Lloyd Wright, *An Autobiography*, 185

This postcard presents another view of the destruction of Taliesin that took place on August 15, 1914, looking up in the northwest direction from the lower level of the living quarters. It is easy to see the limestone mass of the living room fireplace and chimney. Looking closer, surprisingly one can see the partially remaining northeast wall of the kitchen, with its base cabinet and upper shelves with some cooking equipment still in place.

While the tragic murders of Wright's mistress Mamah Borthwick, her two children, and four others left Wright dazed, he eventually found the courage and conviction to build again. "In action there is release from anguish of mind. Anguish could not leave me until action for *renewal*, so far as might be, began. Again, and at once, all that had been in motion before at the will of the architect, if not the man, was set into motion. Steadily, stone by stone, board by board, Taliesin II began to rise from the ashes of Taliesin I. . . . What had been beautiful at Taliesin should live as a grateful memory creating the new, and, come who and whatever might to share Taliesin, they would be sure to help in that spirit."[10]

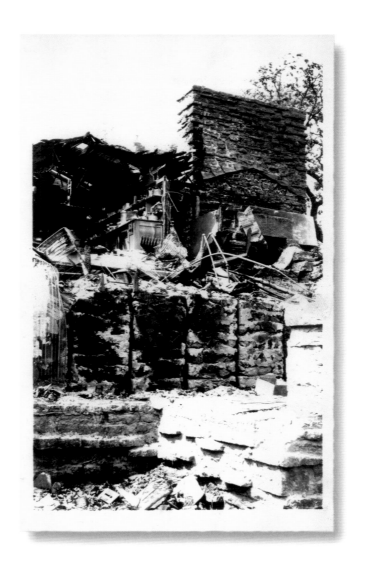

One eleven-year-old was learning to *experience* what he heard, touched or saw. . . .

And the trees stood in it all like various, beautiful buildings, of more different kinds than all the architecture of the world. Some day this boy was to learn that the secret of all styles in architecture was the same secret that gave *character* to the trees.

—Frank Lloyd Wright, *An Autobiography*, 26–27

This postcard image from the late 1920s presents a later, more mature view of the interior courtyard of Taliesin (Taliesin III) as viewed, looking east, from the elevated position of the tea circle through the branches of the expansive oaks.

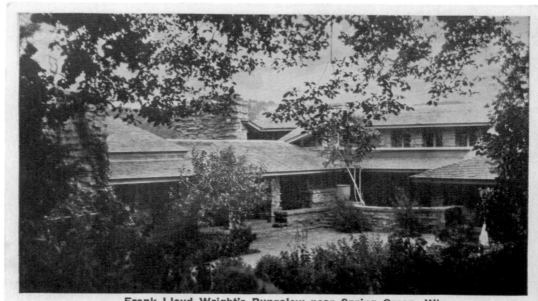

Frank Lloyd Wright's Bungalow near Spring Green, Wis.

This postcard (circa late 1920s), with a handwritten title, "Main Entrance Frank Lloyd Wright Bungalow Near Spring Green, Wis." (and its three unidentified people, including a smiling child with his dog), presents a later view of an expanded Taliesin (Taliesin III). Standing in the interior front courtyard looking southeast directly at the residential wing, the roof of the living quarters has been significantly altered to accommodate an upper (third) floor with exterior balcony. Someone handwrote on the verso of the postcard, "Looking opposite direction from #2 inside of court. Why the hell don't they keep those brats out of the picture?"[11]

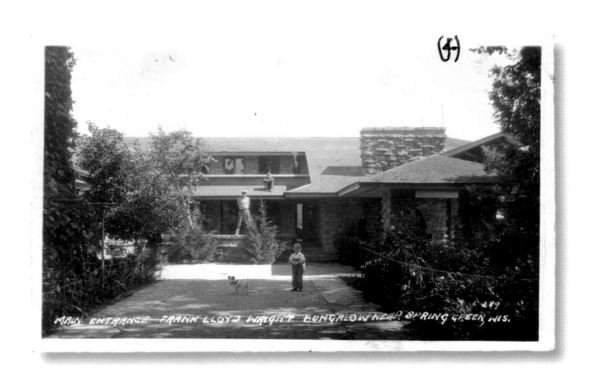

MAIN ENTRANCE FRANK LLOYD WRIGHT BUNGALOW NEAR SPRING GREEN, WIS.

Taliesin was to be an abstract combination of stone and wood as they naturally met in the aspect of the hills around about. And the lines of the hills were the lines of the roofs, the slopes of the hills their slopes. . . .

The shingles of the roof surfaces were left to weather silver-gray like the tree branches spreading below them.

—Frank Lloyd Wright, *An Autobiography*, 171

This postcard, postmarked September 3, 1934, focuses on a southeast view across the studio roofs of Taliesin (Taliesin III) toward the residential wing and the contoured rolling hills of the Valley in the distant background. The lower interior courtyard, upper hill garden, and large oak trees sheltering the tea circle are at the far right. When first built, the roofs of Taliesin were much simpler low-sloped gables. But as opportunities arose and ideas emerged, Wright continuously changed them. He saw all his personal homes as unfinished works always available to his creative energy, never stagnant nor complete.

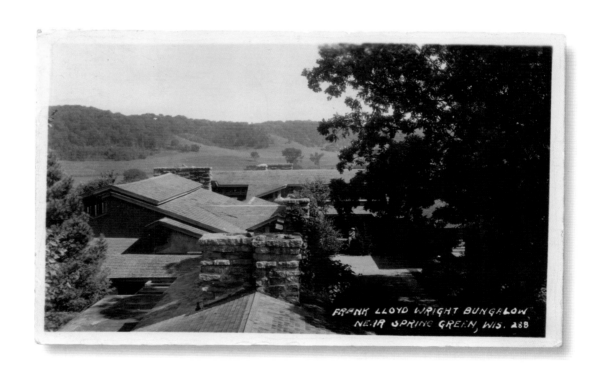

FRANK LLOYD WRIGHT BUNGALOW
NEAR SPRING GREEN, WIS. 288

63

With the Hill Tower being continuously modified (after the 1914 fire and more so after the formation of the Taliesin Fellowship in 1932), this postcard image (circa 1938) looking in the northern direction shows changes when compared to the earlier images of this portion of Taliesin (see page 37). The dovecote has been replaced with a solid plaster wall which expanded the interior space of the tower out to the edge of the overhanging eave. In the highest part of the tower, three dormitory rooms were created for apprentice housing. The massive stone wall at the far left, added in early to mid-1930s, incorporated fireplaces for both the family and fellowship dining rooms. Also note the addition of the speaker box that replaced the bell sitting atop the stone wall right of center. Wright enjoyed broadcasting music throughout the grounds of Taliesin. (Fellowship apprentice Jack Howe was quoted as saying, "There was no escaping Beethoven.")[12] In the fall of 1939 Wright remodeled the dining rooms within the Taliesin Hill Tower, raising the roof of the single story portion and adding a clerestory to allow more light into the interior. Taliesin Fellowship apprentice Curtis Besinger recalled, "Mr. Wright remarked jokingly that 'we should go over and tear the ceiling out of the dining room at Taliesin lest we get soft by eating in finished places.'"[13]

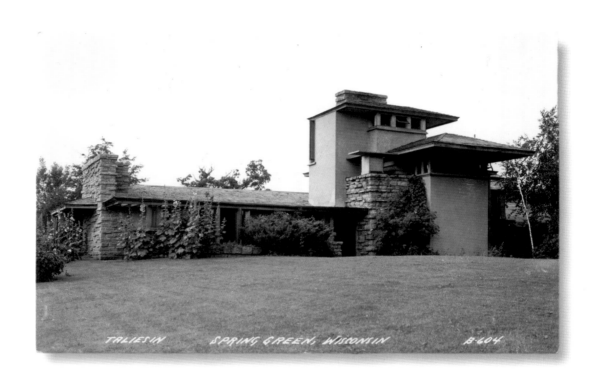

TALIESIN SPRING GREEN, WISCONSIN B-604

Each court had its fountain and the winding stream below had a great dam. A thick stone wall was thrown across it, to make a pond at the very foot of the hill and raise the water in the valley to within sight from Taliesin. The water below the falls thus made was sent by hydraulic ram up to a big stone reservoir built into the higher hill, just behind and above the hilltop garden, to come down again into the fountains and go on down to the vegetable gardens on the slopes below the house.

—Frank Lloyd Wright, *An Autobiography*, 170

Where a meandering creek had existed in the valley below Taliesin, Wright constructed a dam to create a free form pond (romantically referred to as a "water garden").[14] He incorporated a spillway into the design of the dam to create a waterfall feature which was soon made part of the entrance gateway. This postcard (another from the series taken February or March 1914) shows the dam shortly after completion. A portion of the base of the residential portion of Taliesin can be seen in the upper right.[15]

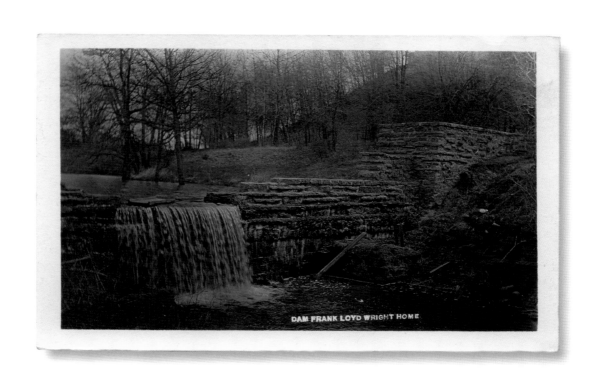

DAM FRANK LOYD WRIGHT HOME

Change being a constant visitor to Taliesin, Wright soon modified the dam and spillway as this postcard (circa 1918) shows. The small rectilinear box at the base of the dam against the bank has now become a higher half-circle plinth of stone, creating a platform, possibly for rest and observation (as suggested by the three unidentified but, nevertheless, posed people in the image). It is interesting to consider that this modification was completed by Wright perhaps as a result of his possible involvement with an earlier design of the dam and opposing observation platforms in nearby Baraboo for the Island Woolen Mills Company.[16]

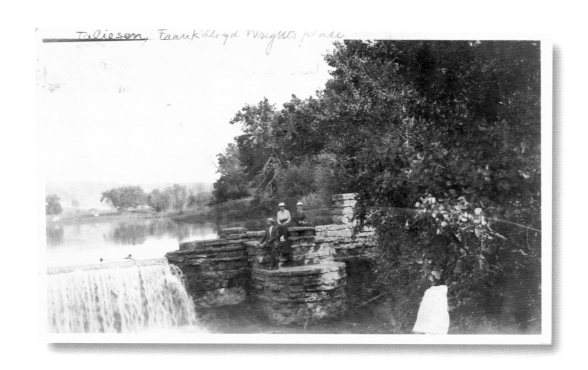

Taliesen, Frank Lloyd Wrights place

Wright's desire for self-sufficiency brought about the installation of a turbine generator at the lower dam. This provided Wright the opportunity to design an enclosure to protect the hydroelectric plant, sometimes referred to as the hydro-house. This evocative hand tinted half-tone postcard image dates to the mid-1920s and shows the simple wood and plaster shelter as constructed beside the dam and waterfall, with the pond and hills in the background. Wright scholar Carla Lind said the hydro-house evokes "the appearance of a Japanese temple sitting on a waterfall."[17]

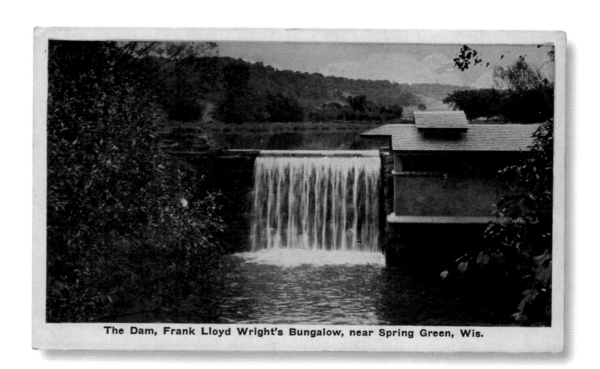

The Dam, Frank Lloyd Wright's Bungalow, near Spring Green, Wis.

While the hydro-house remained for some years, this postcard (circa late 1920s) shows the results of lack of maintenance and the ravages of the constant barrage of water and weather. The plaster wall has been eroded away, leaving other parts remaining but in disarray and disrepair. What was left of the structure was demolished in the mid-1940s during the modifications that took place on the upper and lower dams by Wright and his apprentices.

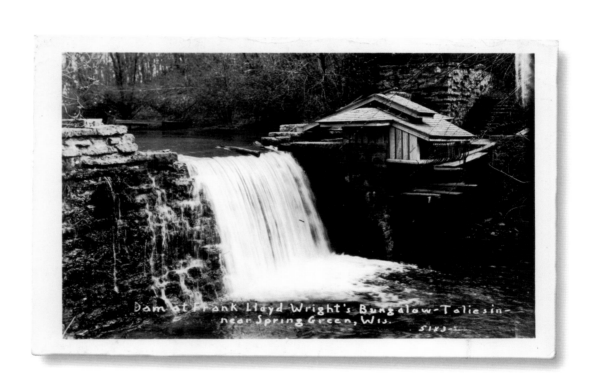

Dam at Frank Lloyd Wright's Bungalow-Taliesin-
near Spring Green, Wis.

HILL/IDE

UNITY CHAPEL, 1886

The little wooden chapel stands in fair repair in the Valley. . . .
 This family chapel was the simple, shingled wooden temple in which the valley-clan worshipped images it had lovingly created.
 —Frank Lloyd Wright, *An Autobiography*, 28–29

Chicago architect Joseph Lyman Silsbee (1848–1913) was the architect for this diminutive but handsome shingle style building, built in the Valley near where Taliesin was eventually built, for Wright's uncle Reverend Jenkin Lloyd Jones (1843–1918) and the Lloyd Jones family. Wright was working as a draftsman for Silsbee at that time and quite possibly, under Silsbee's tutelage, participated in the design. *Unity* magazine stated, "A boy architect belonging to the family looked after the interior."[1] This country chapel's simple form and Silsbee's use of natural materials reflects an architecture that rejected the Victorian style in favor of a design philosophically not distant from the Jones family's. Wright's life as an architect quite possibly began with this project and it is of interest to note that he chose it as his final resting place, in the family cemetery adjacent to the chapel.[2]

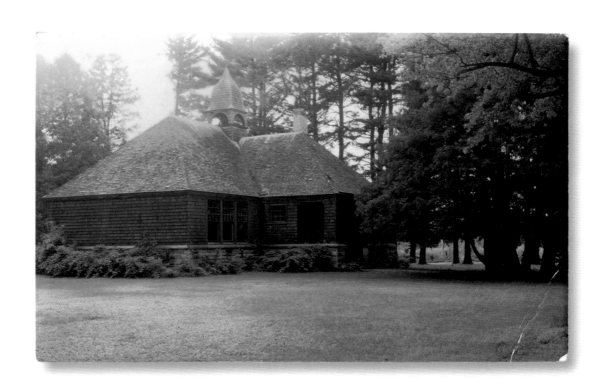

HOME BUILDING, 1887

> At this time in the Valley were two matriarchal maiden sisters of Mother's. They were my Aunts Nell and Jane.
>
> The buildings for the Lloyd-Jones Sisters' Hillside Home School for boys and girls were designed by amateur me. The first one in which to mother their forty or fifty boys and girls was built in 1887. This school, too, had for its crest, "Truth against the World." "The Aunts" built the school on the site of Grandfather's old homestead, adding several new buildings.
>
> —Frank Lloyd Wright, *An Autobiography*, 132

Hillside Home School, a progressive and private institution of education for children ages five to eighteen, was one of the earliest, if not the first coeducational boarding school in the United States. Wright designed the Home Building, his very first commission, for his Aunts' school. This postcard, postmarked April 6, 1908, presents the Hillside Home School campus as viewed from an elevated position looking south. The modified Richard and Mary Lloyd Jones homestead is the multi-gabled structure at the far left with the detached greenhouse/conservatory to its immediate right. The north side of the Home Building is seen just beyond the greenhouse. The gymnasium building (which was later used as a dormitory) is the large building center right. The science portion of the arts and science wing of the Hillside Home School II building is seen immediately behind and to the right of the gymnasium building. The rest of the Hillside Home School II building is hidden behind the arts and science wing by the large trees. Hillside School Road is seen at the far right heading south.

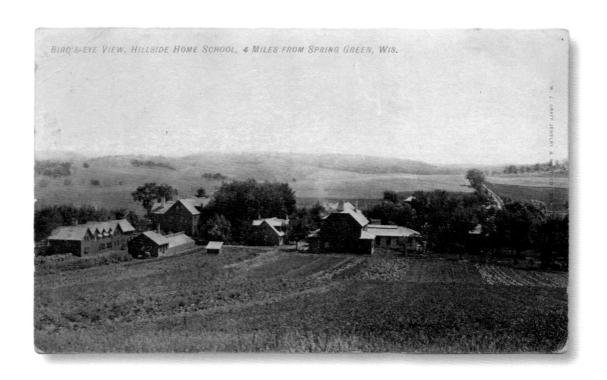

BIRD'S-EYE VIEW, HILLSIDE HOME SCHOOL, 4 MILES FROM SPRING GREEN, WIS.

This postcard provides a picturesque pastoral context of the Hillside Home School, with the numerous cows seen in the pasture. Also prominent in this view looking in the north-northwest direction is the Romeo and Juliet windmill at the far right and the Home Building left of center. The Hillside Home School II building, to the left of the Home Building, is hidden by the trees. Wright's Uncle Thomas Lloyd Jones (1830–1894), the Lloyd Jones' family builder, is thought to have built many of the homes and barns in the area, all the family buildings, and some of the early campus buildings. He also taught shop classes at Hillside Home School.

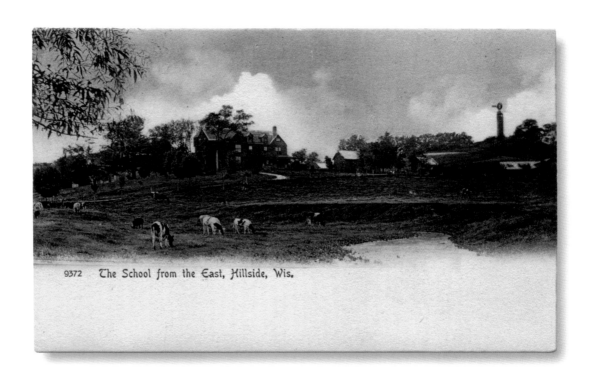

9372 The School from the East, Hillside, Wis.

Presenting a worm's-eye view across the lawn in a north-northwest direction toward the south-facing facade of the Home Building, this postcard was sent on April 6, 1912, by Wright's Aunt Nell to her niece Mary Lloyd Jones at the Abraham Lincoln Center in Chicago. She wrote, "Dear Mary, We are not sure where to find you for an Easter greeting. Heard yesterday you had been to Madison. We wish you had come to see us. Hope your sorrow does not weight quite so heavily upon you. Aunt Jennie and I are very sad and lonely. Lovingly yours, Aunt Nell." As the postcard suggests, 1912 was not a particularly good year in the "Valley of the God-Almighty Joneses." Mary's cousin Margaret had passed away six weeks earlier, on February 27, 1912. Wright had just recently brought scandal to the area when his living with Mamah Borthwick at nearby Taliesin became public knowledge. The Aunts were already financially overextended and, with the added scandal, the school's reputation by association came into question, causing further troubles. Hillside Home School did not survive this series of events and closed late spring 1915.

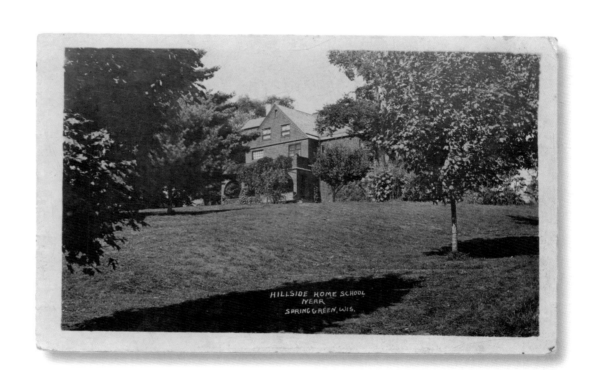

HILLSIDE HOME SCHOOL
NEAR
SPRING GREEN, WIS.

83

His work was a picturesque combination of gable, turret and hip, with broad porches quietly domestic and gracefully picturesque. A contrast to the awkward stupidities and brutalities of the period elsewhere.

—Frank Lloyd Wright, *An Autobiography*, 70

Wright was speaking of his first employer, Joseph Lyman Silsbee. Wright designed the Home Building while employed as a draftsman in Silsbee's office.[3] According to Wright scholar Neil Levine, Silsbee, a proficient architect with offices in Chicago, Syracuse, and Buffalo, "introduced Wright to the Shingle Style mixture of Queen Anne and Colonial elements that formed the basis of his picturesque approach to design."[4] An early mentor of a young Frank Lloyd Wright, Silsbee also employed a number of others who became recognized architects, including George Grant Elmslie (1869–1952), George W. Maher (1864–1926), and Irving Gill (1870–1936). Silsbee's influences are quite evident in the Home Building, as seen in this postcard (postmarked September 21, 1909) of the building's south-facing front with its stone base, shingled exterior, high-sloped roofs, and wraparound sheltered porch.

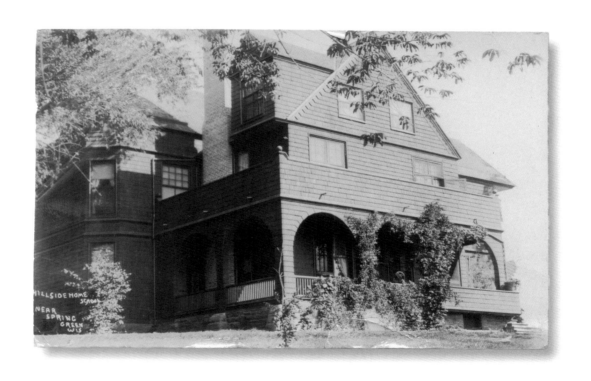

This postcard (postmarked September 1909) provides a clear worm's-eye view of the east side of the Home Building. The Home Building, as described in an article in the local *Weekly Home News* on June 29, 1907, "contains the parlors . . . the dining rooms, living rooms and kitchens, which are all modern and well-equipped. Besides these are twenty-two rooms which are occupied by the girls and some of the teachers. They are all large, well ventilated and sunny. The architecture of this building is English. It has a well kept lawn in which are many grand old trees and beautiful flowers. No attempt is made at landscape gardening, the proprietors seeking only to aid nature, thereby making Hillside a place of simple and natural beauty."

After many unsatisfactory attempts to remodel the building to create a sense of continuity with the nearby Hillside Home School II building, Wright had his Fellowship apprentices demolish the Home Building completely in 1950.

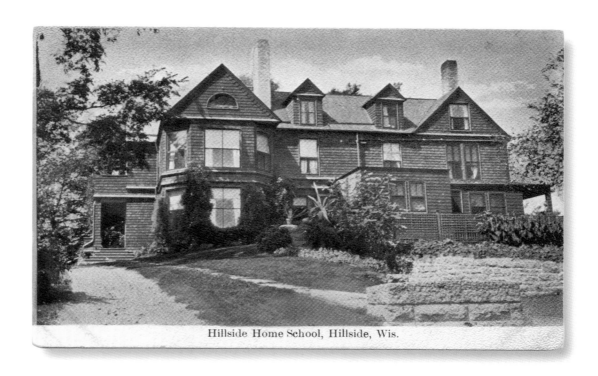

Hillside Home School, Hillside, Wis.

ROMEO AND JULIET, 1896

Said Aunt Nell, managerial mind of the school: "Why not a pretty windmill tower in keeping with our school building instead of an ugly steel tower or, for that matter, the timber ones I have seen? I am going to ask Frank for a design." . . .

The design came. A perspective sketch of the tower in the trees on the hilltop was included with the structural details. The sisters liked it and thought it becoming to the dignity of the beloved school. To the Uncles it looked expensive and foolish. . . .

The telegram—"CRAMER [the builder] SAYS WINDMILL TOWER SURE TO FALL. ARE YOU SURE IT WILL STAND?" Signed AUNT NELL—reached the architect, by now on his own in Chicago.

Came back the answer—"BUILD IT." . . .

DEAR AUNTS NELL AND JANE:

Of course you had a hard time with Romeo and Juliet. But you know how troublesome they were centuries ago. The principle they represent still causes mischief in the world because it is so vital. Each is indispensable to the other . . . neither could stand without the other. . . .

Lovingly, FRANK.

N.B. Romeo and Juliet will stand twenty-five years which is longer than the iron towers stand around there. I am afraid all of my uncles themselves may be gone before "Romeo and Juliet." Let's go.

—Frank Lloyd Wright, *An Autobiography*, 133–36

Wright was correct in his prediction. This postcard, printed sometime between 1925 and the mid-1930s, shows the almost sixty-foot-tall windmill as originally constructed, clad with shingle siding and horizontal wood battens. Interestingly, a more conventional steel tower windmill is seen in the background to the left.

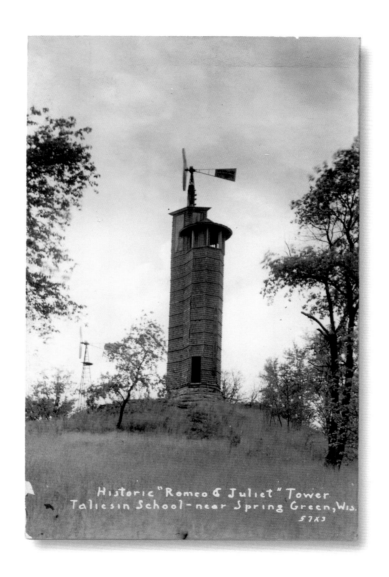

Historic "Romeo & Juliet" Tower
Taliesin School-near Spring Green, Wis.
57X3

The Aunts' windmill, which supplied water to their Hillside Home School from a barren hilltop above, was called Romeo and Juliet by Wright after the obvious parallel with Shakespeare's lovers. "The romanticism of the name perhaps is misleading. It is more than a name, the name is merely because of it. It is an architectural form formed from its structural circumstance. Romeo, the half doing the work of the windmill, slim and tall, diamond shape in plan, half outside forming the 'storm plow,' the other half cutting into the very center of the octagon, Juliet, cuddling along side and surmounted with its belvedere, protected, supported by Romeo. Both parts of the whole and each one the 'better half.' Planned and its shape derived from the purpose that it had to perform on top of that hill-crown against terrific winds."[5] It was an eloquent architectural and aesthetic solution to a basic utilitarian engineering requirement.

With available funds from to the fortuitous Johnson Wax commission, Romeo and Juliet was modified by Wright in 1938—out of both necessity and aesthetic renewal. This post-card shows the horizontal board-and-batten cypress siding, with additional projecting battens at every third board, that replaced the weathered and worn exterior wood shingles. Wright's favored carpenter Bill Weston and Weston's son Marcus did the resurfacing work.

The entire windmill was dismantled and reconstructed in the early 1990s to its 1938 version. Originally costing his Aunts $950 in 1896, ninety-five years later the reconstruction costs approximated $150,000. It was rededicated in June 1992.[6]

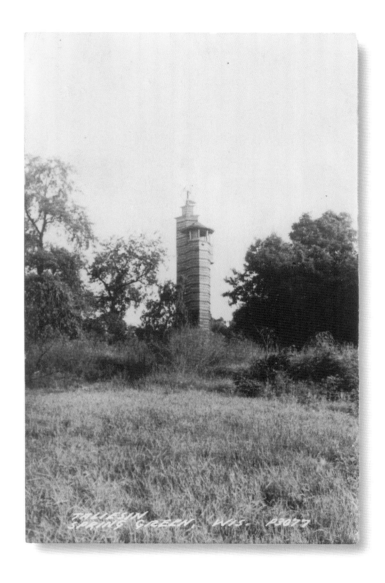

TALLESIN
SPRING GREEN, WIS. R3077

HILLSIDE HOME SCHOOL II, 1901

As seen from State Road 23, looking in the northern direction, this postcard (post-marked July 2, 1908) provides an early view of the Hillside Home School campus in a greater context of the Valley. Included are rare glimpses of the 1896 Romeo and Juliet windmill in its dominant position on the hilltop in the background and (from right to left within the trees) the early Lloyd Jones octagonal barn, the 1887 Home Building, and the 1901 Hillside Home School II building (with the multi-use gymnasium/dormitory building behind). The banks of the stream that meanders through the property to the pond below Taliesin (and eventually into the Wisconsin River) are seen separating the open field in the foreground from the campus. A small bridge can be seen just below and to the right of the barn, under the canopy of a tree.

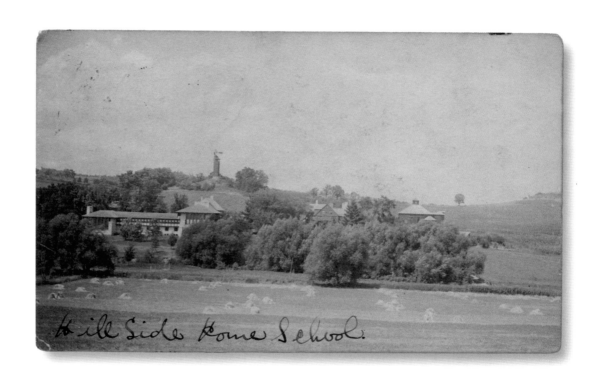

Hill Side Home School.

On September 27, 1907, a cousin of Wright's, Margaret Philip Lewis (1878–1912), wrote on the front of this postcard: "This is where I got my start." The basic elements of the Hillside Home School II building are easily discernable in this image of the south-facing side of Wright's second major contribution to his Aunts' educational campus. Wright created an aesthetic continuity by grounding the entire building upon a solid anchoring foundation, using consistent materials, and providing a sheltered horizontal emphasis with a low-slope hipped roof. Two larger volumes act as terminating sentinels for the two-story row of connecting classrooms. The larger of the two volumes (the form to the right) contains the main assembly room. The volume on the left encloses the gymnasium space. This image clearly presents the building's four levels—a partially buried basement level (accessed through the arched opening below the assembly room at the far right), the gymnasium and lower classroom level, the assembly room and upper classroom level, and the fourth level comprising only the gallery balcony surrounding the assembly room.

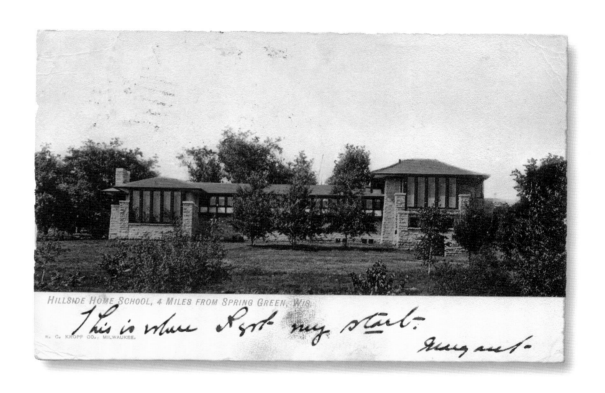

HILLSIDE HOME SCHOOL, 4 MILES FROM SPRING GREEN, WIS.

This is where I got my start.

Frank

The Hillside Home School was perhaps the first—certainly one of the first—co-educational home schools in our country: probably in the world. Mary Ellen Chase has drawn their portraits with a sympathetic hand in her book, *The Goodly Fellowship*.

—Frank Lloyd Wright, *An Autobiography*, 382

This postcard, sent by a young Hillside Home School history and English teacher named Mary Ellen Chase (1887–1973) on April 3, 1912, is another view providing partial glimpses of the Hillside Home School campus. Romeo and Juliet is at the left with the earlier multi-use gymnasium/dormitory building seen to the left of the chimney and a two-story unidentified building and the greenhouse/conservatory in the background at the far right.

Chase went on to become an important literary figure of the early twentieth century. In *The Goodly Fellowship* she wrote, "Upon the site of their farm-house and their own childhood home they erected a large and pleasant house known always as the Home Building. This was designed as a home for girls from thirteen to eighteen. The original house which Richard Lloyd-Jones had built they moved a short distance away, named it Home Cottage, and used as a home for younger girls. They built another small house, beneath the shadow of the northern hill behind the school. This they called West Cottage, and there small boys were placed. Older boys of high school age had their own homelike dormitory near by. In 1903 this was connected with an adequate and beautiful school building of native limestone, designed and erected by Frank Lloyd Wright, the son of Anna Lloyd-Jones and a nephew of Ellen and Jane."[7]

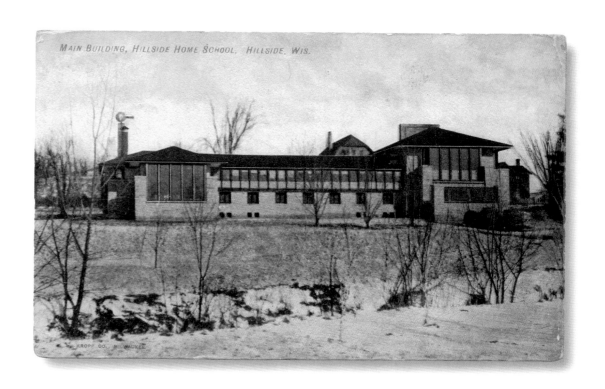

MAIN BUILDING, HILLSIDE HOME SCHOOL, HILLSIDE, WIS.

Three unidentified people provide a sense of human scale to the Hillside Home School II building in this view, postmarked June 20, 1910. Both the primary south-facing facade as well as the west side of the building shown here present a mature combination of three dimensional forms, calculated interplay of surfaces, and the use of common natural materials sandstone, plaster, and wood. Obviously Wright used much more durable materials in this second building he designed for his Aunts' school.

After the Hillside Home School closed the building fell into disrepair due mostly to vandals and general neglect. When Wright established the Taliesin Fellowship in 1932, he began immediately to repair and retrofit the Hillside Home School II building for use by the Fellowship. The gymnasium, shown prominently in this view, was remodeled by Wright into an intimate, two hundred-seat theater where he presented both domestic and foreign films and musical and dancing performances open to the general public. Wright wrote, "Originally we cut up the old Hillside Home School gymnasium and rearranged it into a bright nightspot in Fellowship life."[8] It opened on November 1, 1933. On April 26, 1952, ignited by an out of control brush fire started by Wright, it, along with a portion of the connected classrooms, was completely destroyed down to the foundation stone walls. As he did after both fires at Taliesin, Wright immediately directed the rebuilding, which included a larger theater with entry foyer plus a dining room and kitchen.

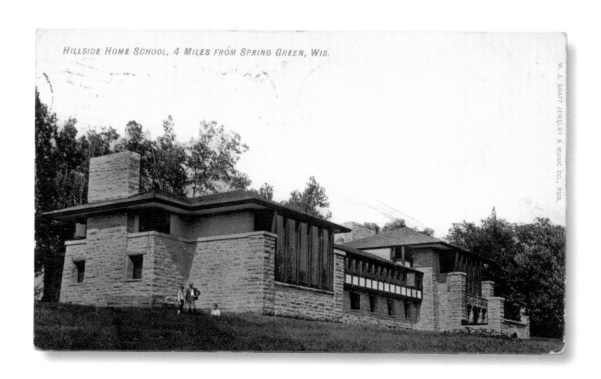

HILLSIDE HOME SCHOOL, 4 MILES FROM SPRING GREEN, WIS.

W. J. GRAFF JEWELRY & MUSIC CO., PUB.

The architect has given us a beautiful and ideal building, and something very much out of the ordinary. He, together with the principals, desired to make it in a way a memorial to his Welsh grandparents, and the whole building is suggestive of the old Celtic structures in Wales.

—*Weekly Home News*, November 6, 1902

This postcard provides a close-up view, looking northeast, of the south-facing facade. The sandstone walls, both vertical and battered, visually and structurally emanate from the ground supporting the plaster, wood trim, and roof above. The windows for the lower story are punched through the thick stone wall. Above the stone foundation wall, the upper classrooms are cantilevered out from the lower wall, with their windows grouped together above a horizontal line of plaster and separated vertically with wood trim. The assembly room is the large volume at right.

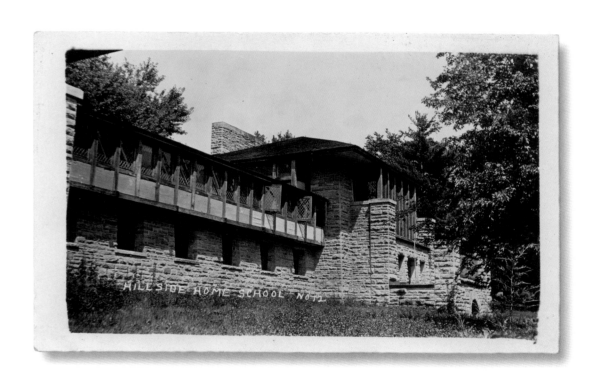

This postcard (postmarked March 12, 1914), looking in the west-northwest direction, provides another clear close-up of the south facade. The assembly room is the volume in the foreground at the right of the image with the gymnasium anchoring the building in the background at the left. The original leaded glass windows are evident in this view, as are the arched opening to access the basement and another punched opening containing windows for the space below the assembly room. Wright replaced all the leaded glass windows with plate glass in 1932 during the repair and retrofit of the building. The original intended use of the small exterior patio above the arched basement access, with its vertical slatted rail between the stone piers, has long been forgotten.[9]

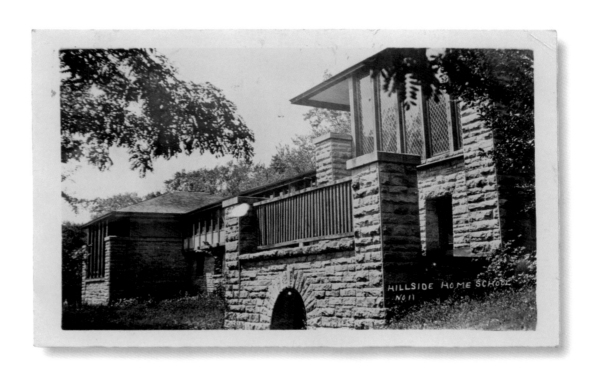

On August 6, 1906, Wright's cousin Margaret Philip Lewis wrote on the front of this postcard, "This is a part of my Aunts' school building." The image is a view, looking in the westerly direction, of a portion of the east facade looking toward the main entrance into the building. The assembly room is the larger volume on the left. Dominating the south and east walls of the assembly room are its five tall vertical windows grouped together to bring light into the two-story interior. Wright placed a gallery balcony around the perimeter of the upper assembly room but designed it in such a way that it was free from the exterior wall where these five grouped windows were placed. It was early evidence of Wright's interior spatial experiments toward the destruction of the box. The shorter leg of the building's L shape is shown here with the entrance and bridge connecting to the arts and sciences wing to the far right.

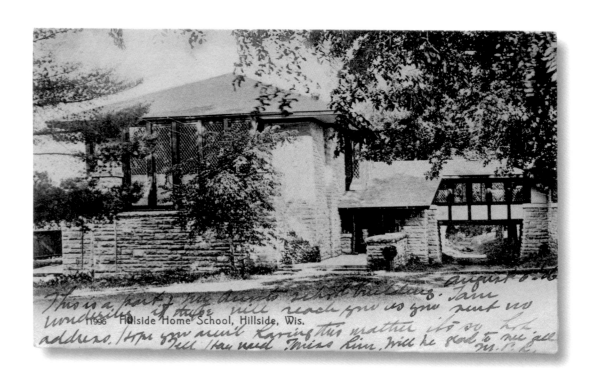

11596 Hillside Home School, Hillside, Wis.

This postcard presents a closer partial view of the previous image. Looking west at the east-facing side of the Hillside Home School II building, its main entrance, connecting bridge, and driveway are prominent. The assembly room is the form to the left. The main entrance into the building, located just below the sloping roof above and to the left of the extended sandstone wall and walkway, is actually on the half level between the gymnasium and lower classroom level below and the assembly and upper classroom level above. The bridge seen above the driveway connects the main building with the skylit arts and science wing at the far right. The corner of the art room can be seen in this image and the science laboratory is beyond to the west behind the bridge out of view.

Wright client Susan Lawrence Dana (1862–1946) loaned Wright's Aunts $27,000 for the construction, equipment, and furnishings for this wing, with another Wright client, Charles E. Roberts (1843–1934), adding an additional $9,000. In 1934, when Wright was constructing the large studio wing adjacent to the north wall of the arts and science wing, he dedicated the arts and science wing to the patronage of their benefactors. The Dana Gallery and Roberts Room were slated for exhibition use.

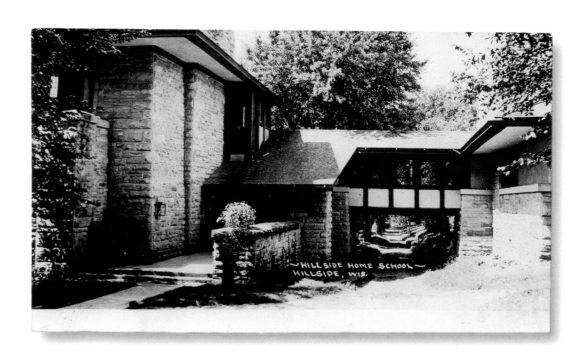

EPILOGUE

Again Taliesin! Three times built, twice destroyed, yet a place of great repose....

At sunrise last late September I stood again with bare feet on the virgin sod of the Taliesin hill-crown....

Many but not so many dreams of the future? Moments of anguish? Oh, yes—of course—there are many, but no moment of regret. Day by day I enjoy more the eternity that is now. At last, I am realizing that eternity *is* now. And that eternity only divides yesterday from tomorrow.

It is now as though the mind itself at times were some kind of recording film in endless reel, to go on perfecting and projecting picutres endlessly, seldom if ever the same as the moment changes. But the same scene and scheme may show itself from infinitely varying angles as the point of view changes if informing principle, the *impulse* living in it all, stays in place. Else the impotence of confusion, the chaos of madness: vain imprisonment in the Past.

No—the several years since Taliesin first steeled itself and settled down to its work and its ideal have been free, but of course they have not been carefree. Sad memories not excluded—they have been happy years. Short. And Hope never really dies. Because of those troubled years, my life is richer than ever before.

—Frank Lloyd Wright, *An Autobiography*, 368–69

The original entry gate into Taliesin as seen from within the property looking north, out toward County Highway C and the hills beyond. The extent of the lower limestone walls are evident in this postcard view (circa 1918). Like the entry sequences and experiences to most of his earlier Prairie homes, the explorative circuitous route through the entrance gateway signaling one's crossing from the public road to the private domain at Taliesin almost seventy-five feet above was not the result of accidental chance—it was carefully choreographed by Wright for purposes of both experiential and protective measures. While this gateway hasn't functioned as Taliesin's primary entrance since circa 1930 (and the ironwork and planter urns are long gone), the enveloping limestone walls and terminating piers nevertheless remain extant adjacent to Taliesin's lower dam.

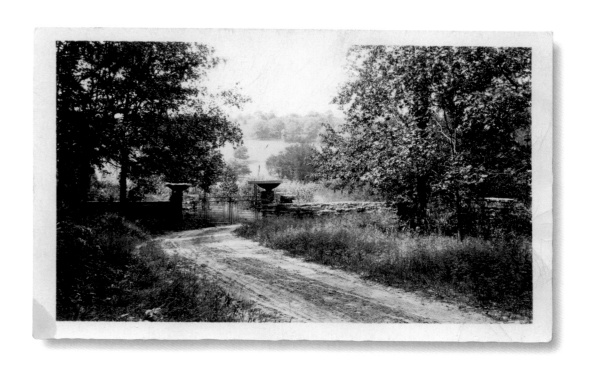

Here on this low hill in THE VALLEY there is Freedom to make life and work really synonymous terms. In the retrospect is a vast panorama of life. Human experience a colorful tapestry shot through with threads of gold as light gleams whenever truth is touched and love rose worthy of noble selfhood or life rose higher because of death.

Or where living faith justified defeat.

Sincerely sought, well-loved, may be seen that principle—is it the very quality of life itself vaguely felt by the boy as left out in that early lesson preached by familiar feet in the snow up the slope of the valley field? . . .

And I have been seeking ideal life as I have been seeking ideal building, just as at the beginning of "An Autobiography" I sought naked weed rising above blue arabesque, sunshot on spotless white.

Thus my life has been, as it must be, a changing test of Principle. Eternal.

—Frank Lloyd Wright, *An Autobiography*, 376

Frank Lloyd Wright posed for this postcard at Taliesin in the early 1940s.

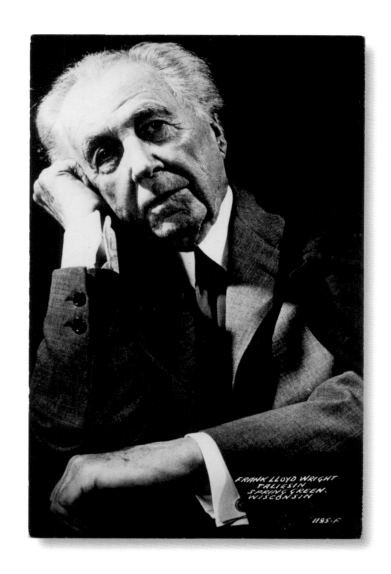

NOTES

INTRODUCTION

1. The Valley was settled by Wright's grandparents Richard (1799–1885) and Mary Lloyd Jones (1808–70) in the late fall of 1844. Taliesin is pronounced Tally-ES-in.

2. As referred to by Wright's sister Maginel Wright Barney in her book *The Valley of the God-Almighty Joneses.*

3. Wright, *An Autobiography,* 168.

4. Ibid., 170.

5. Ibid., 171.

6. In 1903 Wright designed a house in Oak Park for Edward and Mamah (Borthwick) Cheney. In 1909 Wright and Mamah left their respective spouses and families and traveled together to Europe while Wright was working on the preparation of his Wasmuth portfolio. After Mamah returned in June 1911 she sought and was given a divorce from her husband in August 1911. It was then that she reverted to her maiden name.

7. Levine, The Architecture of Frank Lloyd Wright, 76.

8. Wright, *An Autobiography,* 167.

9. As evidenced by a postcard in the collection of Patrick J. Mahoney, on the back of which was written, "This is the love cottage where those people were killed," and another in the author's collection stating, "This is a scene of that love cottage I was telling you about."

10. Wright, *An Autobiography,* 167.

11. Ibid., 18.

12. Ibid., 508.

13. Wright quoted in Pfeiffer and Nordland, *Frank Lloyd Wright: In the Realm of Ideas,* 40.

14. On August 15, 1914, caused by a deranged servant, and on April 20, 1925, caused by faulty wiring (and a third less severe fire occurred in February 1927, only causing an estimated $3,000 worth of damage).

15. Wright, *An Autobiography,* 273.

16. Quoted with permission, e-mail from Margo Stipe, Curator and Registrar of the

Collections, Frank Lloyd Wright Archives, to author, dated August 5, 2010.

17. Because of the two devastating fires, the original Taliesin is sometimes called Taliesin I. Taliesin II spans the time between the two fires (1914 to 1925), and Taliesin III from 1925 until Wright's death in 1959. However, this nomenclature is misleading due to Wrights affinity for constantly changing Taliesin as well as the fact that much of Taliesin remained unaffected by the fires (i.e., the architectural studio, Hill Tower, etc.). So, in effect, the three numerical designations might refer to the general rebuilding of only the residential portion of the entire complex.

TALIE/IN

1. There are ten known postcards in this series of various views of Taliesin plus one of the Hillside Home School's Home Building and one of the Taliesin dam (page 67). Ten are printed herein.

2. Aguar and Aguar, *Wrightscapes*, 151.

3. Menocal, *Wright Studies*, 100.

4. This postcard was from a scrapbook owned by Svetlana Peters (1917–46).

5. Wright traveled to Japan in 1904 with his first wife Catherine (1871–1959) and clients Ward and Cecilia Willits, again in 1913 with Mamah Borthwick, and five additional times between 1916 and 1922 during the design and construction of the Imperial Hotel, four out of the five trips with his second wife Miriam Noel (1869–1930).

6. Meech, *Frank Lloyd Wright and the Art of Japan*, 265.

7. Mamah Borthwick, her twelve-year-old son John and eight-year-old daughter Martha, draftsman Emil Brodelle, Wright's carpenter Billy Weston's thirteen-year-old son Ernest, gardener David Lindblom, and workman Thomas Brunker all perished.

8. Wright, *An Autobiography*, 185.

9. Ibid., 186–88.

10. Ibid., 189–90.

11. This postcard was from a scrapbook owned by Svetlana Peters.

12. Taliesin Associated Architects, *Romeo and Juliet: Historic Structure Report*, Appendix 3.

13. Besinger, *Working with Mr. Wright*, 26.

14. See sketch of Taliesin grounds by C. H. Ashbee in *Western Architect*, February 1913.

15. I am indebted to Keiran Murphy of Taliesin Preservation, Inc., for sharing with me her research regarding the history of the lower dam and hydro-house.

16. While the Frank Lloyd Wright Archives does not list this project in Wright's official list of works, several noted Wright scholars (Carla Lind in *Lost Wright: Frank Lloyd Wright's Vanished Masterpieces* and William Allin Storrer in *The Architecture of Frank Lloyd Wright: A Complete Catalog*) present arguments for its inclusion.

17. Lind, *Lost Wright*, 27.

HILLSIDE

1. Gannett, "Christening a Country Church," 356–57.

2. After Wright's wife Olgivanna's death in 1985, in accordance with her burial instructions, Wright's body was exhumed, cremated, and interred together with Olgivanna's ashes in an undisclosed location at Taliesin West in Scottsdale, Arizona.

3. Wright worked in Silsbee's office most of 1887.

4. Levine, *The Architecture of Frank Lloyd Wright*, 3.

5. Henning, *At Taliesin*, 45.

6. "News from Taliesin," 9. For information relative to the windmill's history, the 1938 modifications by Wright, and early 1990s restoration, see *Romeo and Juliet: Historic Structure Report* by Taliesin Associated Architects.

7. Chase, *A Goodly Fellowship*, 97–98.

8. Wright, *An Autobiography*, 444.

9. This curious patio might have been designed for clothes drying, as the laundry was located just inside this area. The plans provide no further clues. However, no exterior door onto the patio from the laundry was shown on the plans and questions exist if the area below the assembly room was ever used as the school's laundry.

SELECTED BIBLIOGRAPHY

Aguar, Charles E., and Berdeana Aguar. *Wrightscapes: Frank Lloyd Wright's Landscape Designs*. New York: McGraw-Hill, 2002.

Ashbee, C. R. "Taliesin, the Home of Frank Lloyd Wright, and a Story of the Owner." *Western Architect* 19 (February 1913): 16–19.

Barney, Maginel Wright (with Tom Burke). *The Valley of the God-Almighty Joneses*. New York: Appleton-Century, 1965.

Bencini, Roberta, and Paolo Bulletti. *Frank Lloyd Wright in Fiesole: One Hundred Years Later 1910 / 2010*. Firenze, Italy: Giunti Editore, 2010.

Besinger, Curtis. *Working with Mr. Wright: What It Was Like*. Cambridge, England: Cambridge University Press, 1995.

Chase, Mary Ellen. *A Goodly Fellowship*. New York: Macmillan, 1939.

Cowles, Linn Ann. *An Index and Guide to an Autobiography: The 1943 Edition by Frank Lloyd Wright*. Hopkins, Minnesota: Greenwich Design Publications, 1976.

Gannett, William C. "Christening a Country Church." *Unity* 178 (August 28, 1886): 356–57.

Hamilton, Mary Jane. "Tan-y-deri: Another View of Taliesin's Unfolding Narrative." *Frank Lloyd Wright Quarterly* 17, no. 3 (Summer 2006): 4–23.

Henning, Randolph C. *At Taliesin: Newspaper Columns by Frank Lloyd Wright and the Taliesin Fellowship, 1934–1937*. Carbondale: Southern Illinois University Press, 1992.

Hildebrand, Grant. *The Wright Space: Pattern and Meaning in Frank Lloyd Wright's Houses*. Seattle: University of Washington Press, 1991.

"Hillside: Where the Past and Future Meet." *Frank Lloyd Wright Quarterly* 12, no. 2 (Spring 2001): 4–21.

Levine, Neil. *The Architecture of Frank Lloyd Wright*. Princeton: Princeton University Press, 1996.

Lind, Carla. *Lost Wright: Frank Lloyd Wright's Vanished Masterpieces*. San Francisco: Pomegranate Communications, 1996.

McCarter, Robert. *Frank Lloyd Wright*. London: Phaidon Press Limited, 1997.

Meech, Julia. *Frank Lloyd Wright and the Art of Japan: The Architect's Other Passion*. New York: Japan Society and Harry N. Abrams, 2001.

Menocal, Narciso, ed. *Wright Studies: Volume One*. Carbondale: Southern Illinois University Press, 1992.

Murphy, M. Keiran, and Anne E. Biebel. *Hillside Comprehensive Chronology*. July 2010.

"News from Taliesin: The Return of Romeo and Juliet Windmill." *Frank Lloyd Wright Quarterly* 3, no. 4 (Winter 1992): 9

Pfeiffer, Bruce Brooks, and Gerald Nordland, eds. *Frank Lloyd Wright: In the Realm of Ideas*. Carbondale and Edwardsville: Southern Illinois University Press, 1988.

Smith, Kathryn. "Frank Lloyd Wright and the Imperial Hotel: A Postscript." *The Art Bulletin* 67 (June 1985): 296–310.

————. *Frank Lloyd Wright's Taliesin and Taliesin West*. New York: Harry N. Abrams, 1997.

Smith, Kathryn, and Alan Weintraub. *Frank Lloyd Wright: American Master*. New York: Rizzoli, 2009.

Storrer, William Allin. *The Architecture of Frank Lloyd Wright: A Complete Catalog*. 3rd ed. Chicago: University of Chicago Press, 2002.

"The Studio-Home of Frank Lloyd Wright." *Architectural Record* 33 (January 1913): 45–54.

Taliesin Associated Architects. *Romeo and Juliet: Historic Structures Report*. March 15, 1991.

"Taliesin: A Work of a Lifetime." *Frank Lloyd Wright Quarterly* 6, no. 3 (Summer 1995): 12–17.

"Taliesin: A Work of a Lifetime." *Frank Lloyd Wright Quarterly* 18, no. 4 (Fall 2007): 4–23.

Taliesin Preservation, Inc., and Isthmus Architecture, Inc. *Tan-y-deri: Historic Structures Report*. October 2001.

Weil, Zarine. *Building a Legacy: The Restoration of Frank Lloyd Wright's Oak Park Home and Studio*. San Francisco: Pomegranate Communications, 2001.

Wright, Frank Lloyd. *An Autobiography*. New York: Duell, Sloan & Pearce, 1943.

ACKNOWLEDGMENT/

I wish to thank those anonymous individuals and commercial companies that were involved in the photographing and printing of these vintage postcards. Their unsung and silent contribution remains the focus of this book. My ability as an author certainly will never be without substantial cooperation, assistance, and support from my friends and colleagues, Frank Lloyd Wright scholars, and certain institutions. This book is no exception. Special thanks go to Patrick J. Mahoney and Phil H. Feddersen, who allowed me to augment the failings of my collection with postcards from their personal collections, and to John Hime, Patrick J. Meehan, William B. Scott Jr., George Shutack, and Brian A. Spencer for offering their collections as well. Frank Lloyd Wright scholars, whose work both directly and indirectly has made this book significantly better, include Anthony Alofsin, Mary Jane Hamilton, Jack Holzhueter, Neil Levine, Carla Lind, Robert McCarter, and Narciso G. Menocal. I also need to acknowledge Carol Johnson as well as the significant contribution and tireless cooperation of Keiran Murphy, both of the Taliesin Preservation, Incorporated, and Anne Biebel, of Cornerstone Preservation, for sharing with me an early draft of her comprehensive chronology of the Hillside Home School. For permission to quote from Frank Lloyd Wright's *An Autobiography* and the use of several vintage postcards from their collection, I wish to thank the Frank Lloyd Wright Foundation and Archives (Scottsdale, Arizona) and, individually, Bruce Brooks Pfeiffer, Oskar Muñoz, Margo Stipe, and Indira Berndtson. Suzette Lucas, editor of *Frank Lloyd Wright Quarterly*, provided early encouragement for this project. The Visual Materials Collection within the Division of Library Archives of the Wisconsin Historical Society (Madison, Wisconsin) provided additional postcards for study and use; thanks go to David R. Benjamin and Lisa Marine for their assistance. The University of Wisconsin Press deserves special credit for their vision to recognize the validity of this book with only a concept to consider initially. The staff at UWP assisted greatly in the successful realization of this book, especially Raphael Kadushin, Katie Malchow, Adam Mehring, and Carla Marolt. I also thank Thomas A. Heinz and the anonymous reviewer who, for the University of Wisconsin Press, reviewed the book's concept when it was just an idea and saw the merits to pursue publication. Kathryn A. Smith deserves a multitude of thanks on many levels—for her friendship, guidance, scholarship, encouragement, and confidence in me and this project and, of

course, for her well-written foreword. Finally, it never goes without saying that I wouldn't be what I am without the love and support of my parents James and Shirley Henning, my two incredible boys Michael and Christopher, and, last but never least, my beloved wife and best friend Maggie.

Errors within are all mine and I apologize up front for those wholeheartedly. While I have attempted to make every effort to locate and contact copyright holders of copyrighted material contained in this book, if I have failed at any point in this task then I trust and ask that my failing will be excused.

ILLUSTRATION CREDITS

From the author's collection: 2, 13, 17, 21, 23, 25, 27, 29, 39, 41, 43, 45, 49, 53, 55, 65, 67, 73, 83, 89, 93, 101, 103, 113; 11, 33 (printed by L. L. Cook, Lake Mills, Wisconsin); 35 (printed by the Co-Mo Company, Minneapolis, Minnesota); 63 (printed by Moen Photo Service, La Crosse, Wisconsin); 71 (printed by the Auburn Greeting Card Company, Auburn, Indiana); 79, 99 (printed by W. J. Graff Jewelry & Music Company); 81, 105 (printed by the Rotograph Company, New York & Germany); 87 (printed by J. W. Zangl, Jeweler & Optician, Spring Green, Avoca & Arena, Wisconsin); 95, 97 (printed by E. C. Kropp Company, Milwaukee, Wisconsin); 107 (printed by the Gem Photo Company, Freeport, Illinois)

Courtesy of the Wisconsin Historical Society: viii (WHi-68050), 51 (WHi-55871), 57 (WHi-55870), 69 (WHi-38772)

From the collection of Patrick J. Mahoney, used with permission: 15, 19, 31, 47, 85; 59 (printed by Auburn Greeting Card Company, Auburn, Indiana); 91 (printed by the L. L. Cook Company, Milwaukee, Wisconsin)

From the Frank Lloyd Wright Archives, courtesy of the Frank Lloyd Wright Foundation: 37, 61 (printed by the Moen Photo Service, La Crosse, Wisconsin); 77 (printed by the Photo Center, Darlington, Wisconsin)

From the collection of Phil H. Feddersen, used with permission: 37